Heaven & Earth

COLOURING BOOK FOR ADULT'S RELAXATION

Colouring used to be reserved for children and the occasional adult who got to babysit a child. However, recently, colouring has found a niche in the adult market.

What started as a hobby for some, has now turned into a worldwide trend, as adult colouring books find themselves on more and more best sellers' lists throughout the world.

However, while this trend may be a fun way to keep you entertained, it's the book's therapeutic properties that really have them flying off shelves.

AUTHORS: SOLÉ PAEZ - PHOTOGRAPHER
& XIMENA VARAS - ILLUSTRATOR

This work is copyright. Apart from any use permitted under the Copyright Act 1968, no part may be reproduced by any process, nor may any other exclusive right be exercised, without the permission of Solé Paez (Photographer) and Ximena Varas (Illustrator).

COVER & INTERIOR DESIGN: SOLÉ PAEZ & XIMENA VARAS
AVAILABLE FROM AMAZON.COM AND OTHER RETAIL OUTLETS

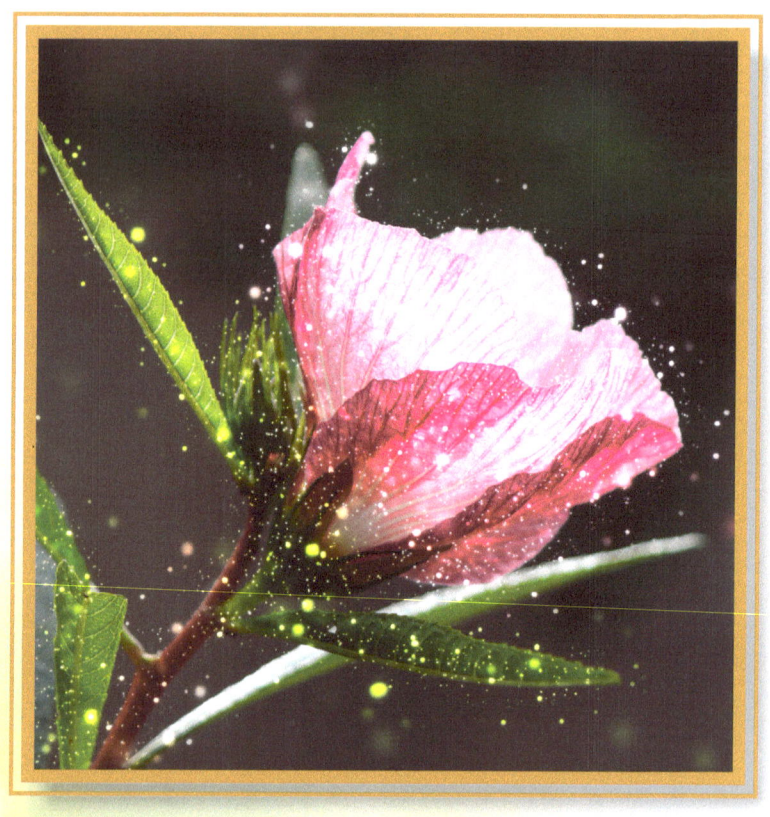

"You have to take risks. We will only understand the miracle of life fully when we allow the unexpected to happen."

Paulo Coelho

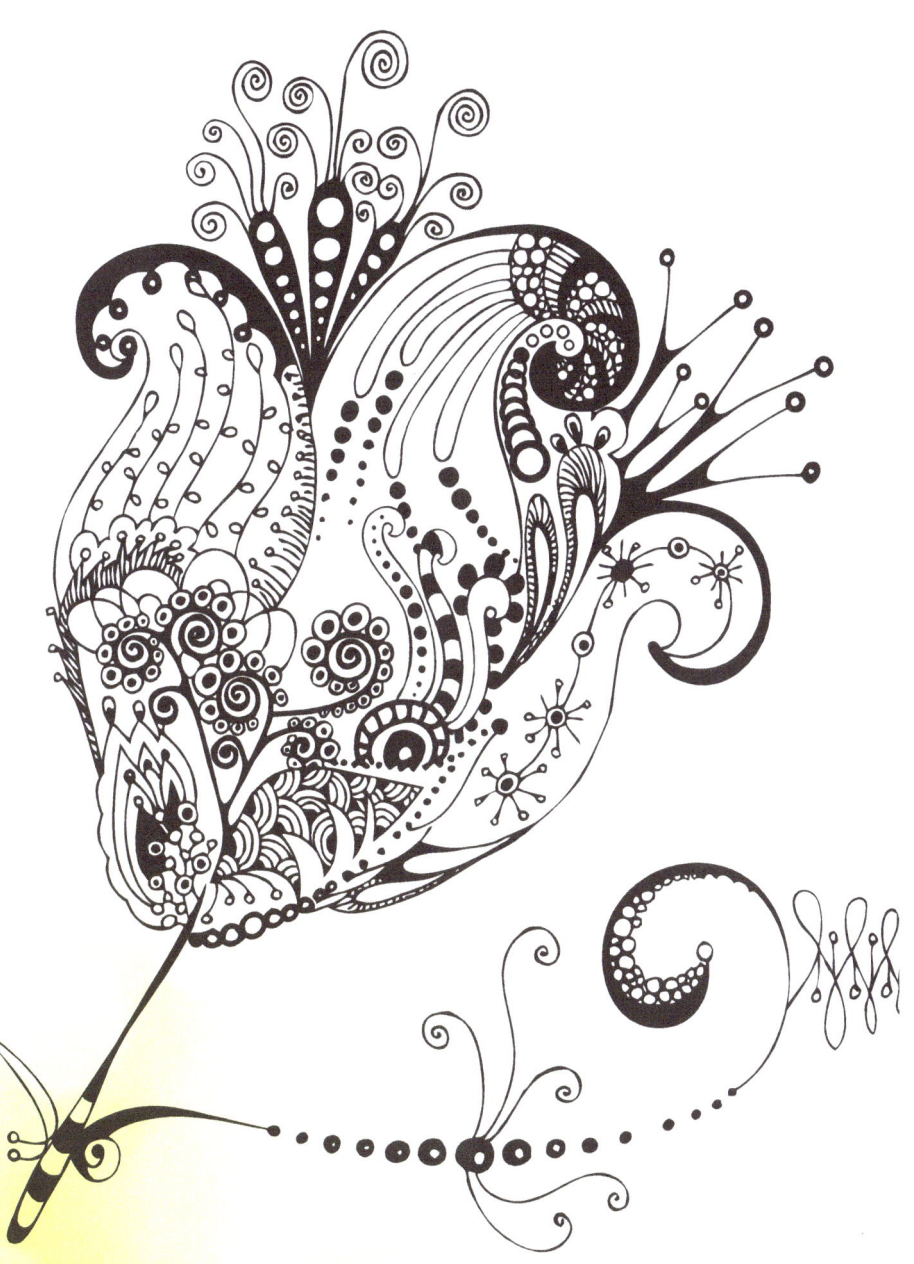

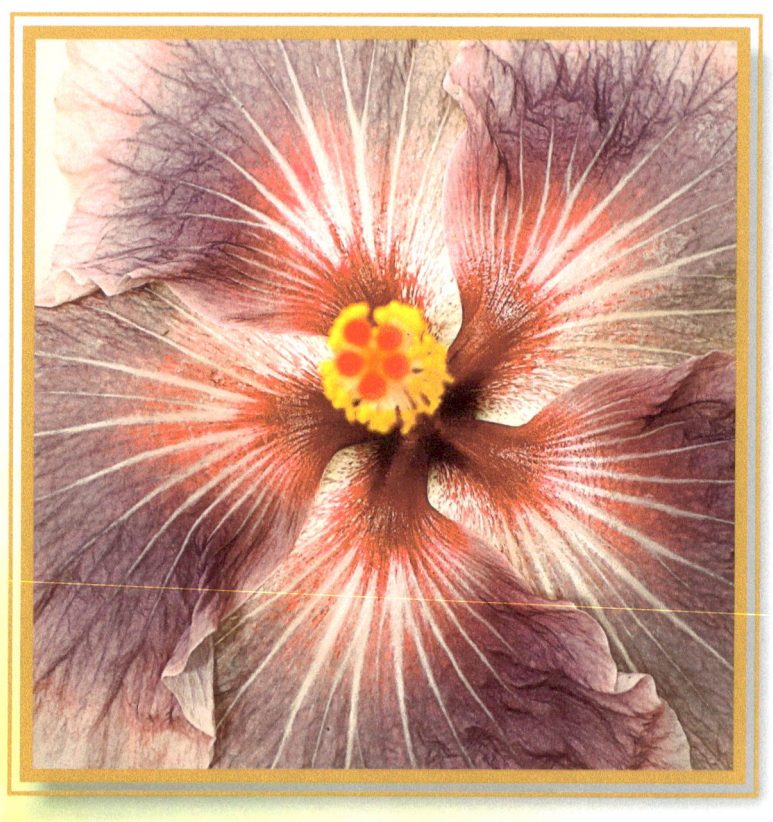

"Keep your face always toward the sunshine, and shadows will fall behind you."

Walt Whitman

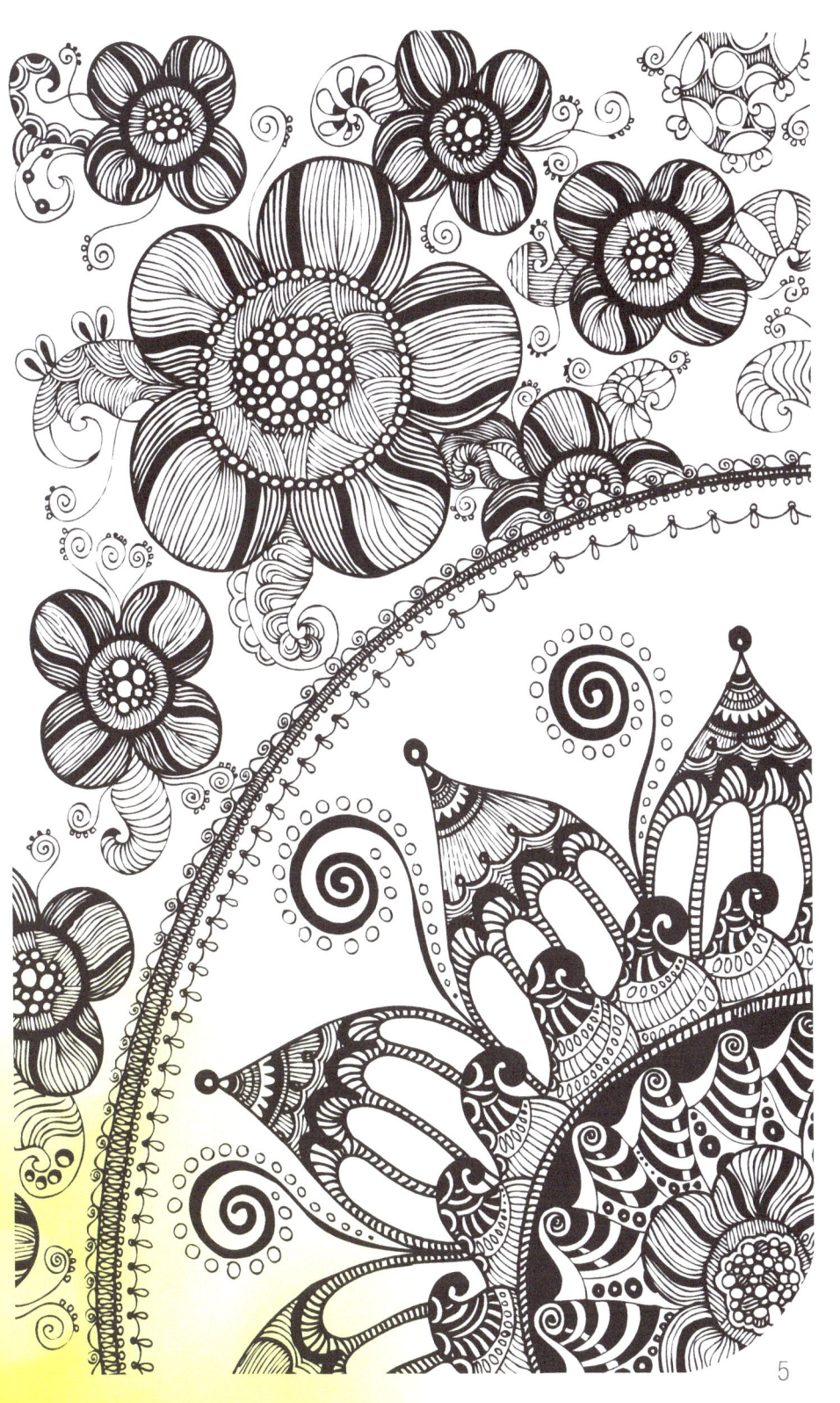

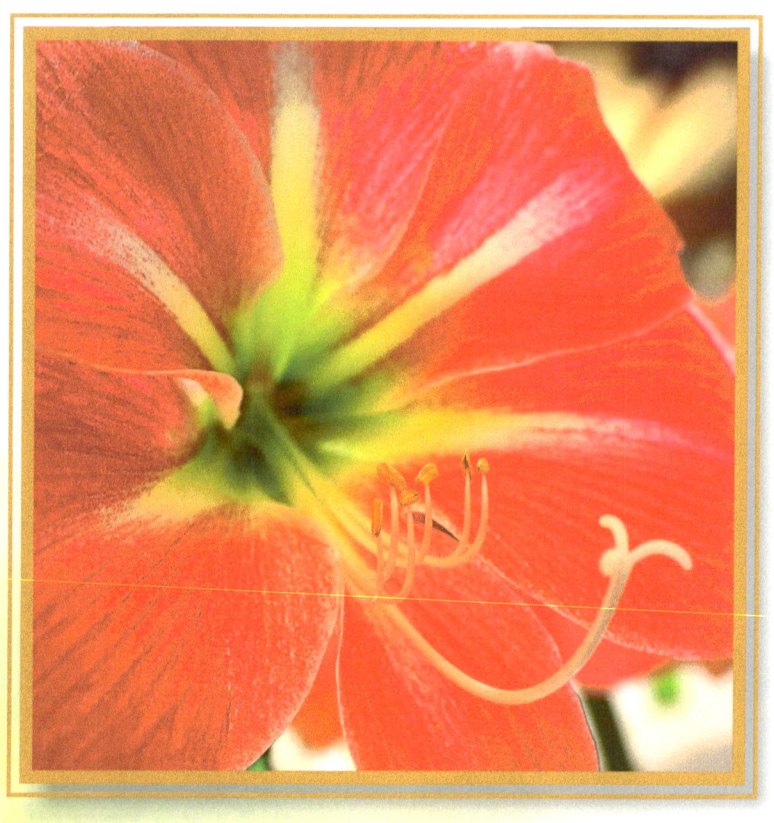

"I will always find a way and a way will always find me."

Charles F. Glassman

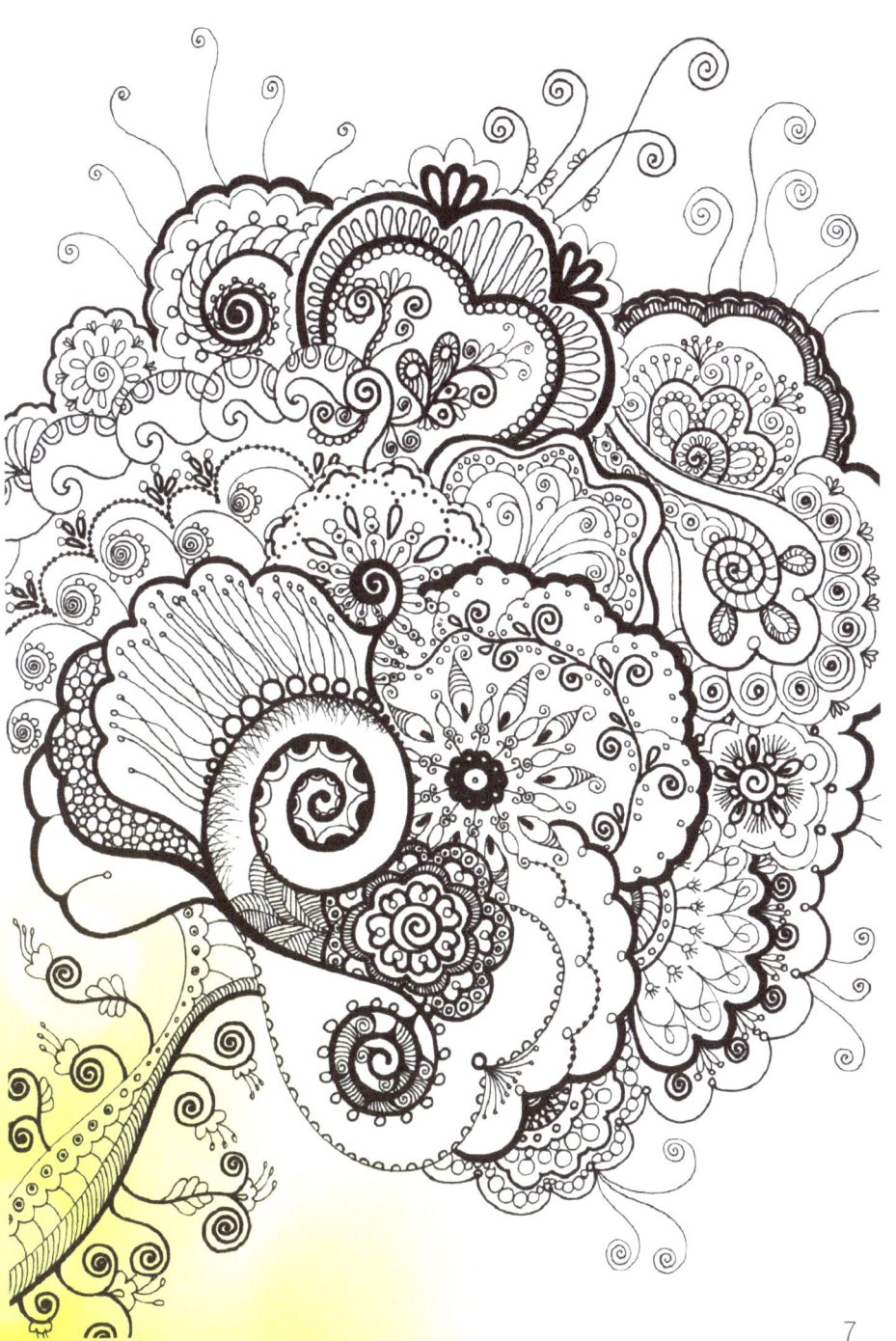

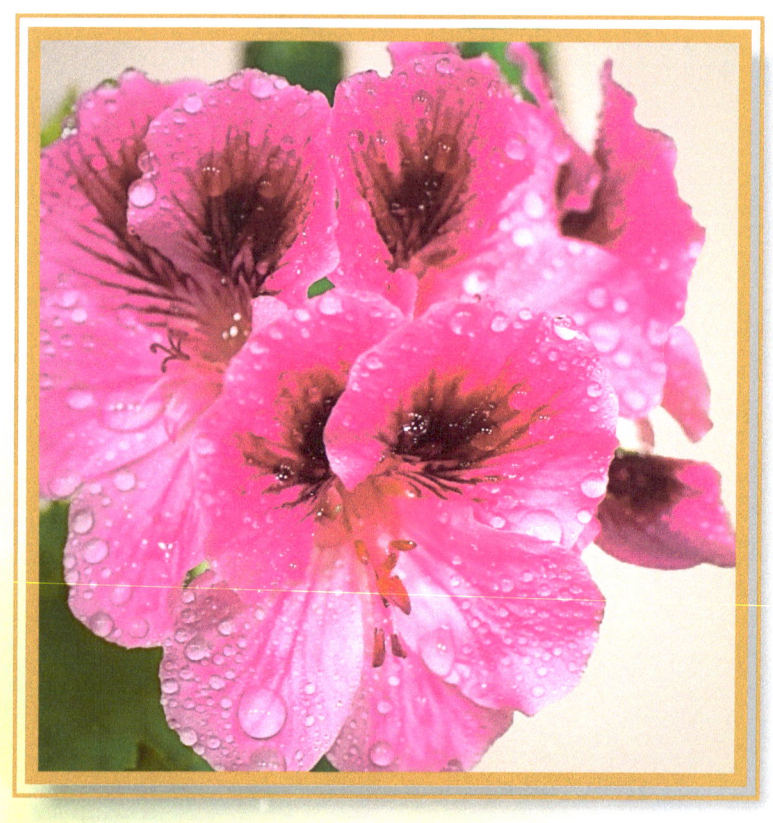

"Truth always prevails, as it packs the mightiest punch of them all!."

Dee Waldeck

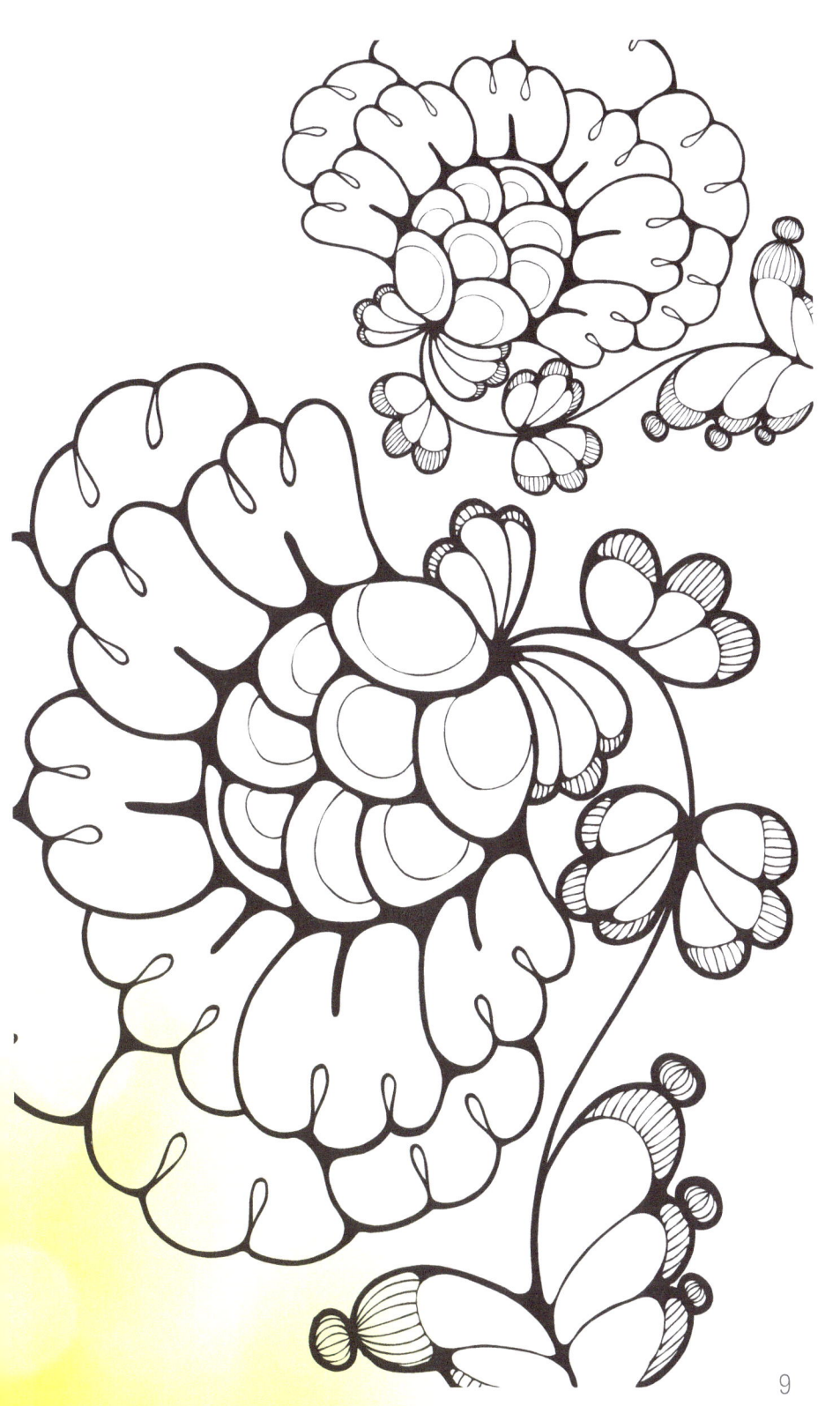

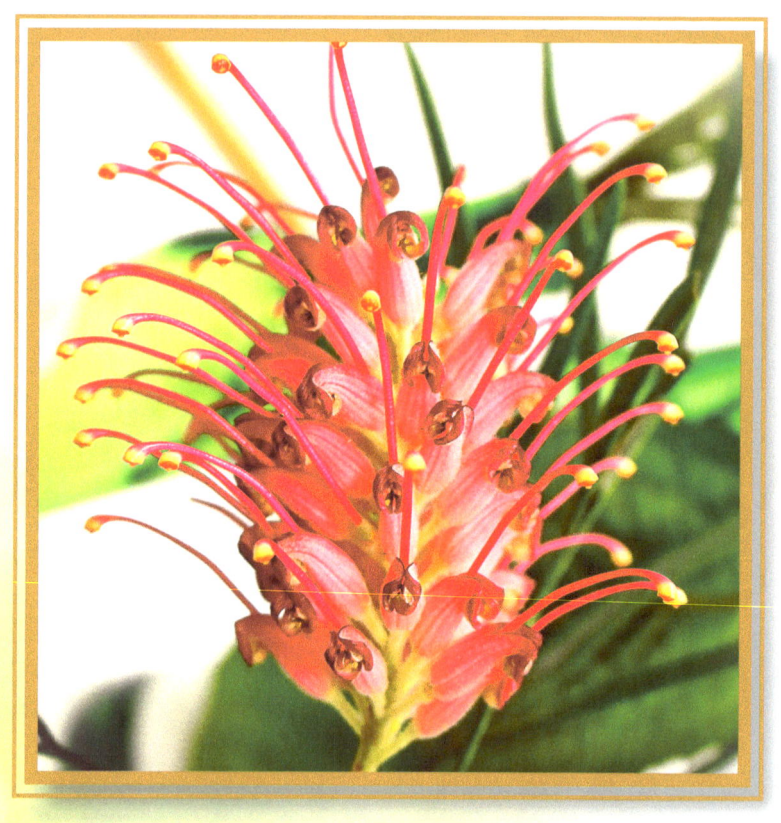

"Chase your dreams with all your strength, soul and sprit."

Lailah Gifty Akita

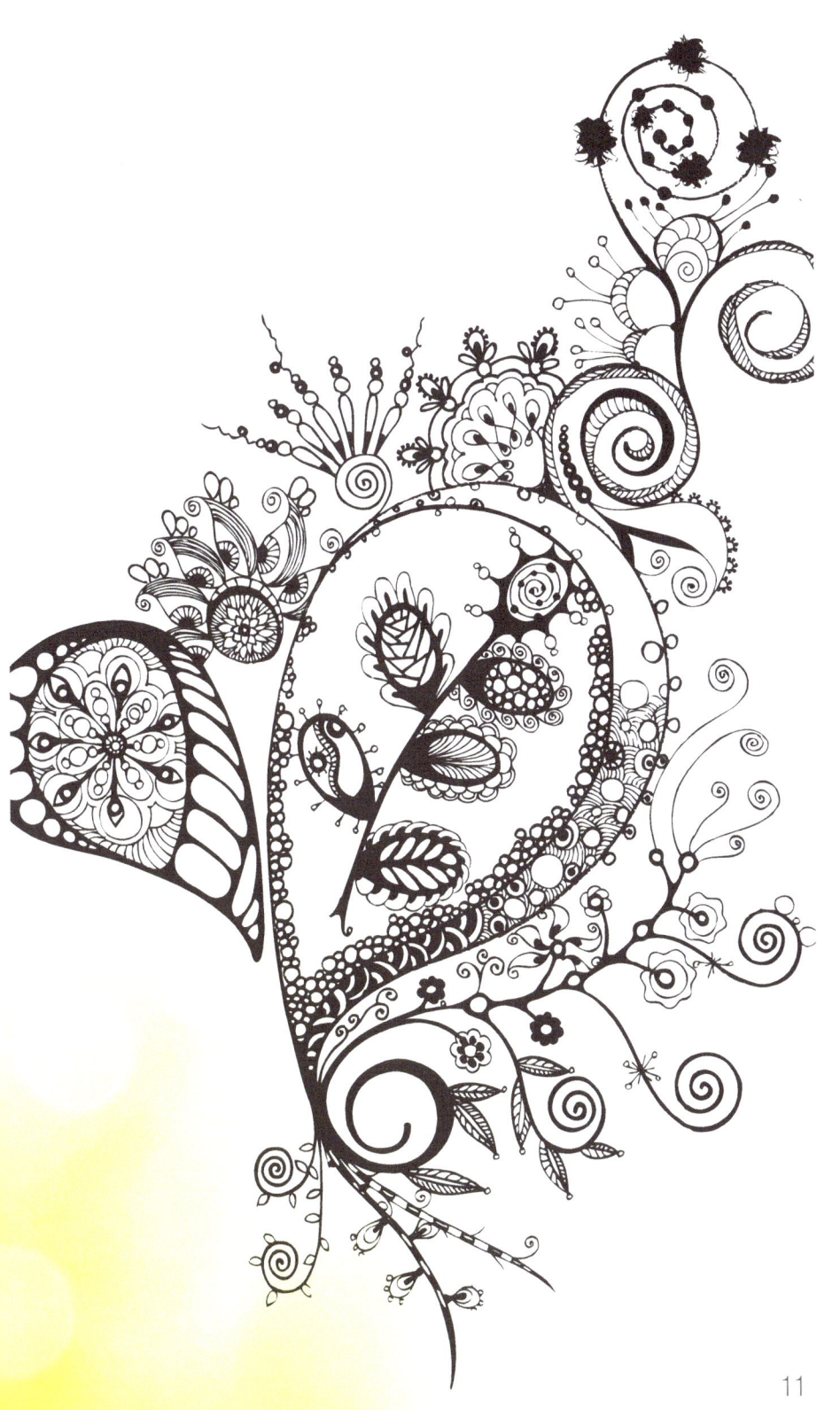

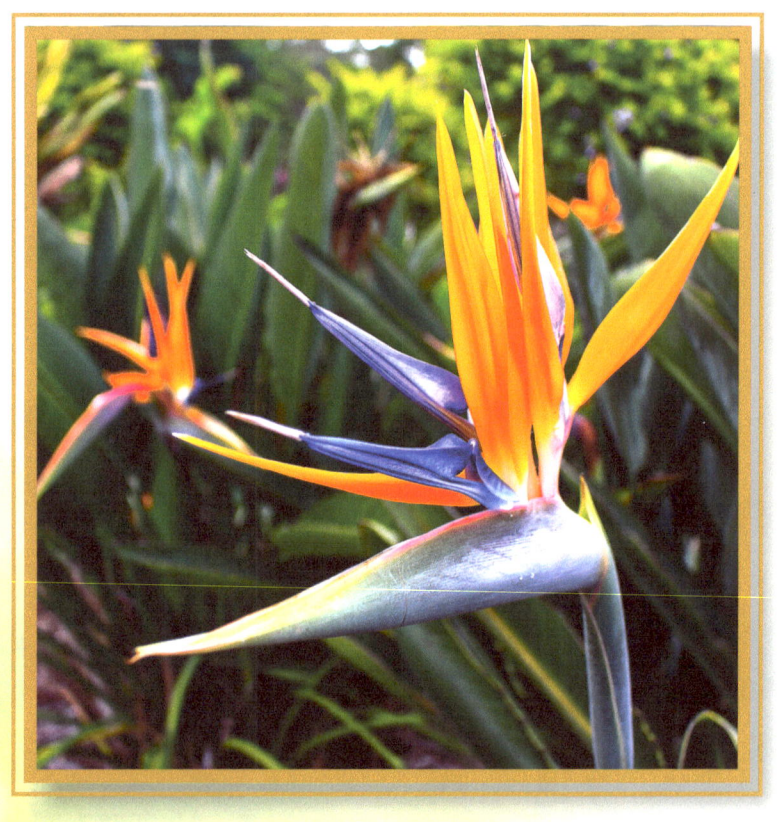

"Dare to shine as if you were the brightest star."

Anonymous

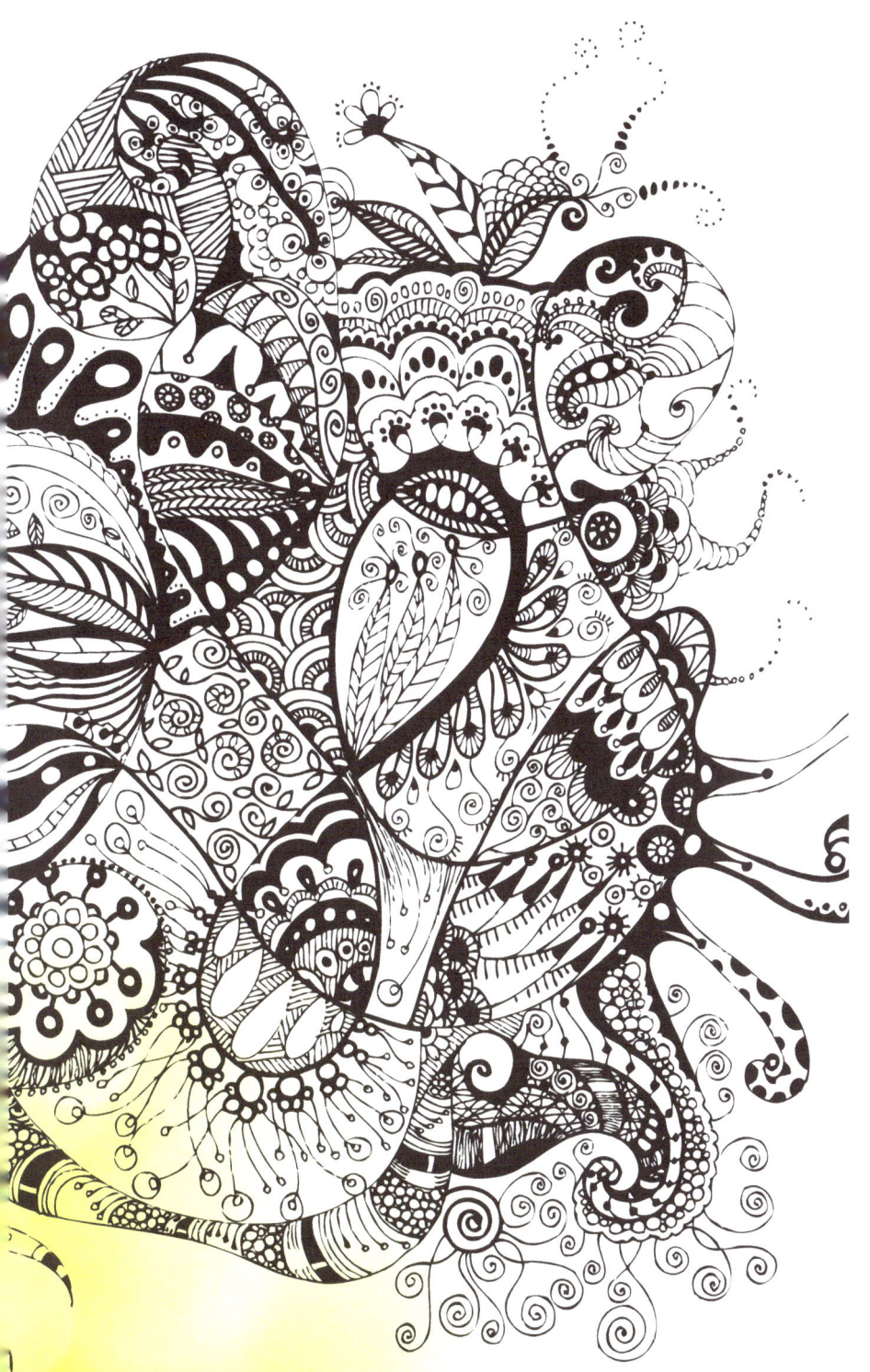

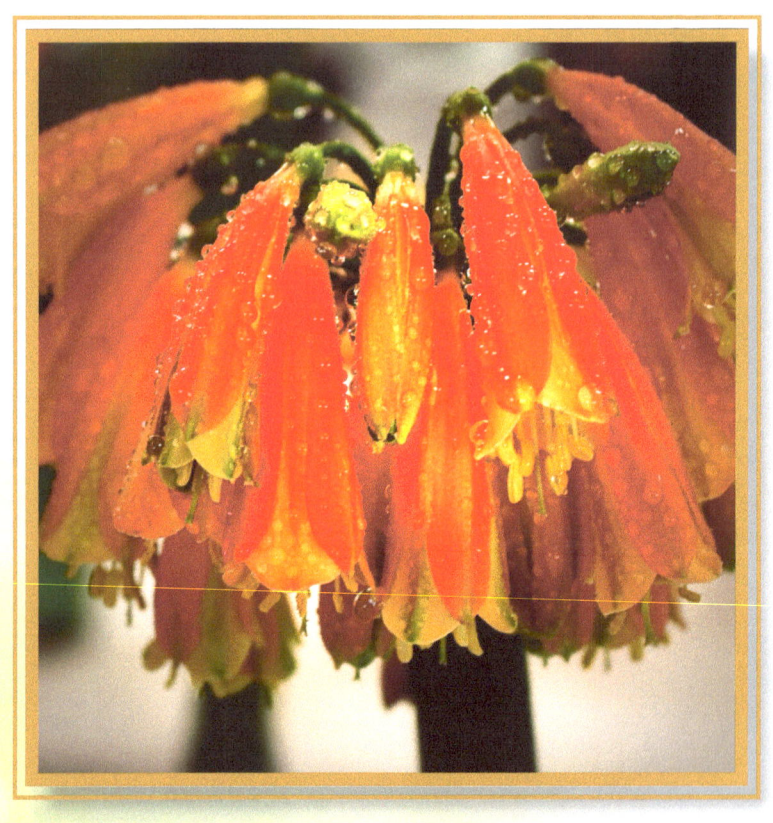

"Your VISION and your self-willingness are the MOST powerful elements to conquer your goal."

Rashedur Ryan Rahman

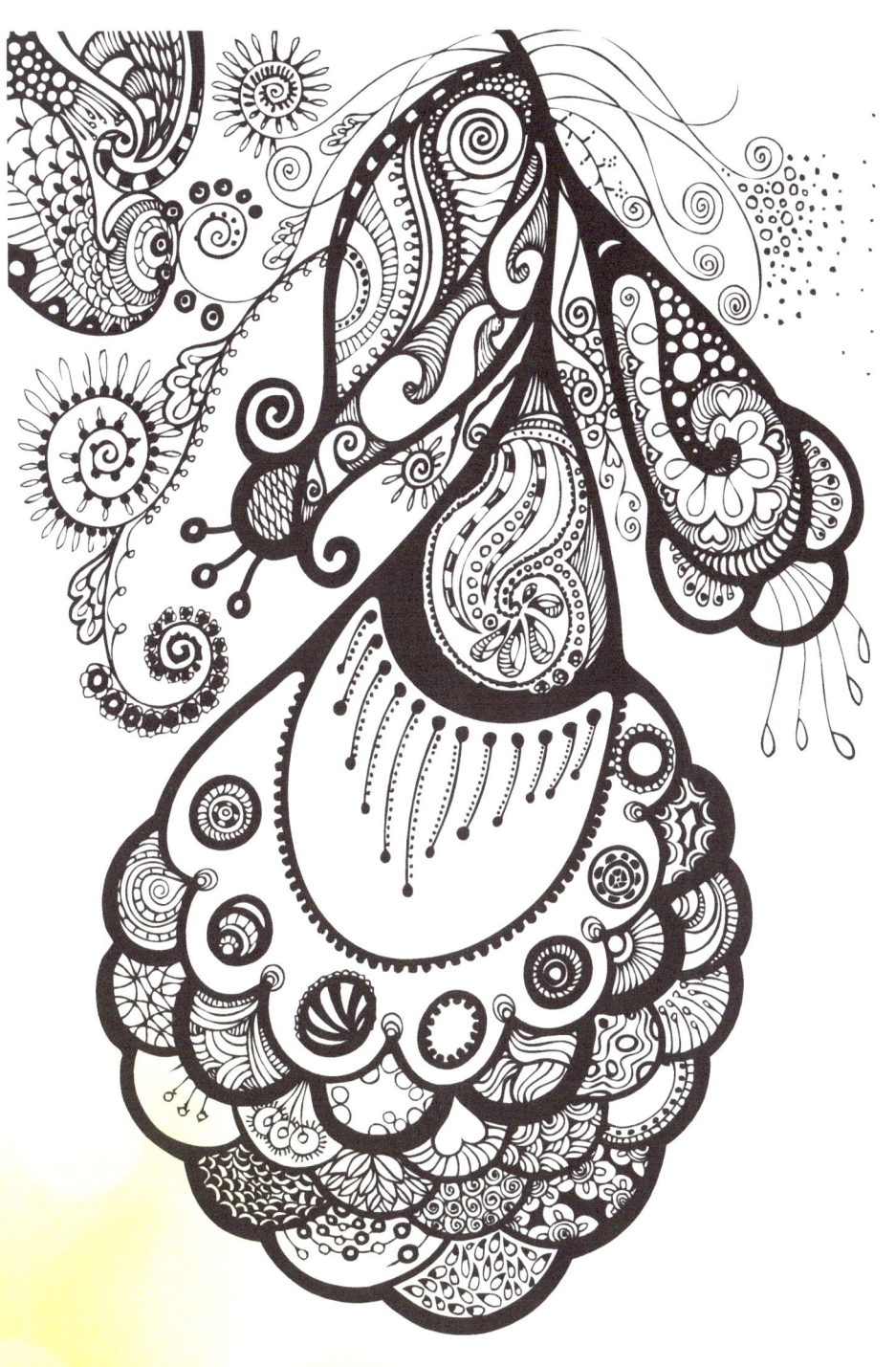

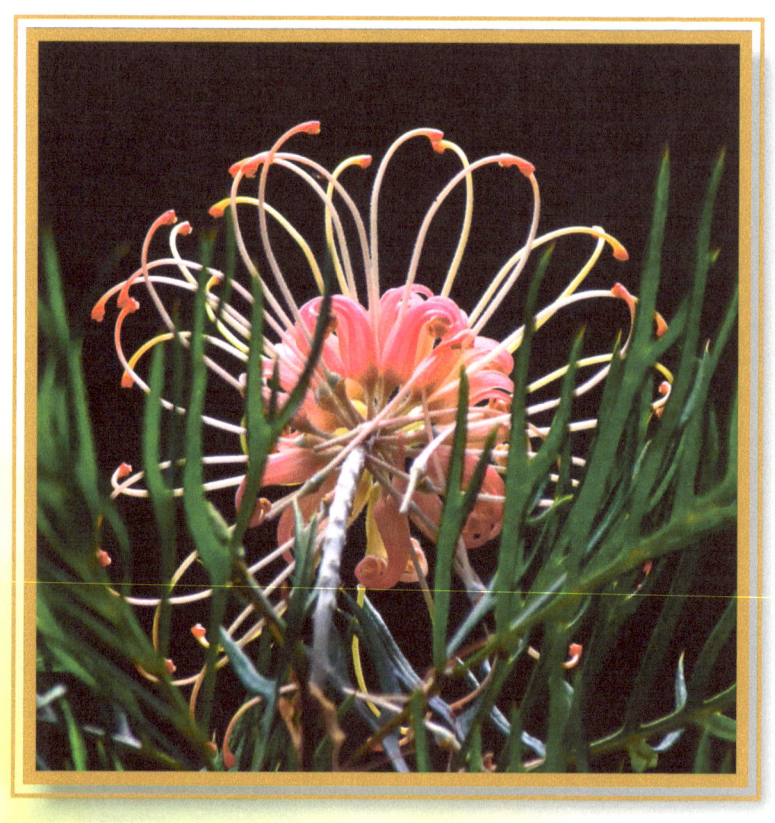

"Everything in the world is potentially yours.
Don't limit yourself to your own means."

Bangambiki Habyarimana

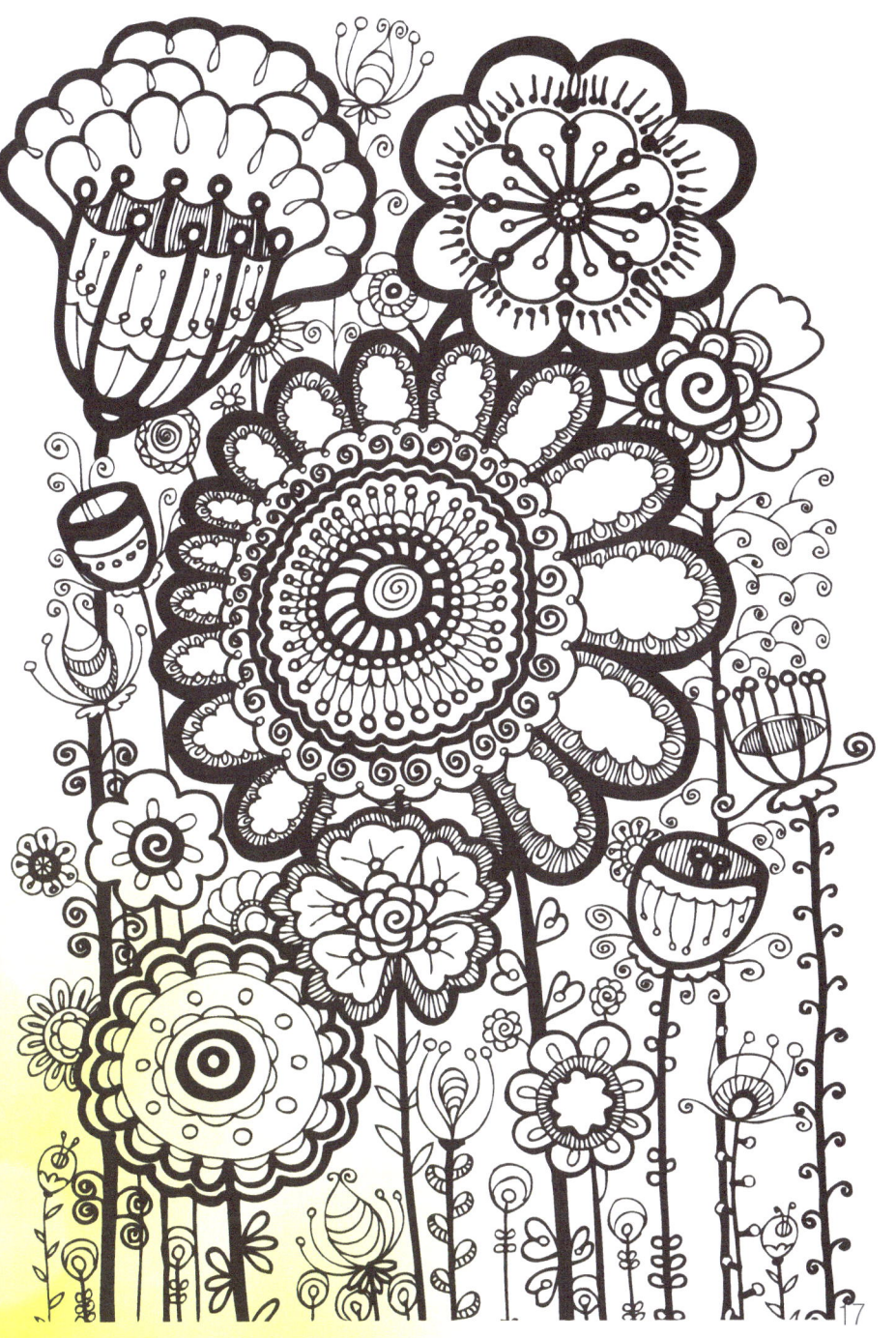

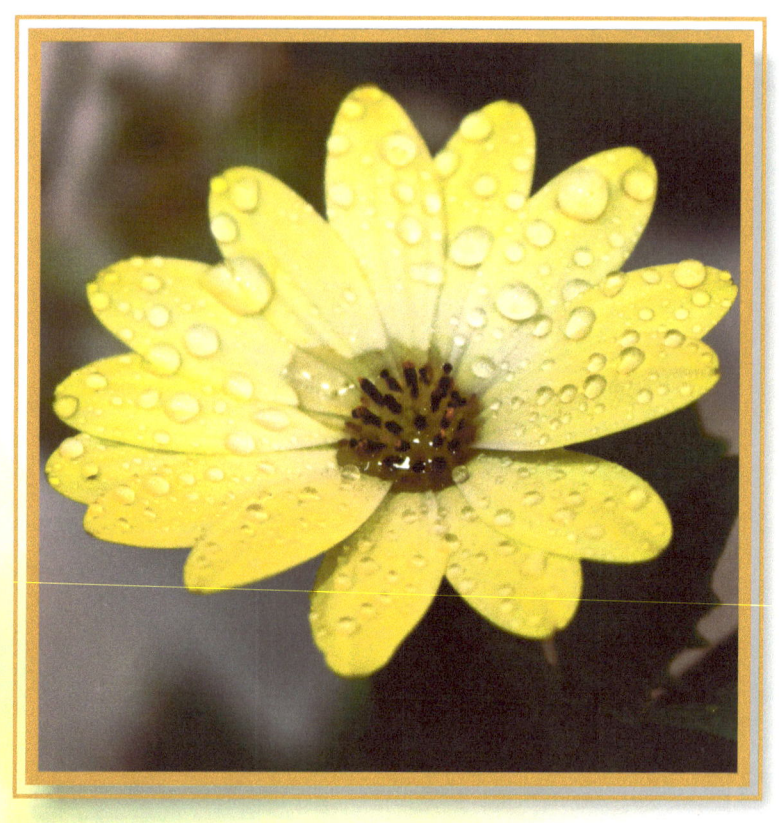

"As you become more present in your own life,
you will begin to enlighten others
by your example."

Germany Kent

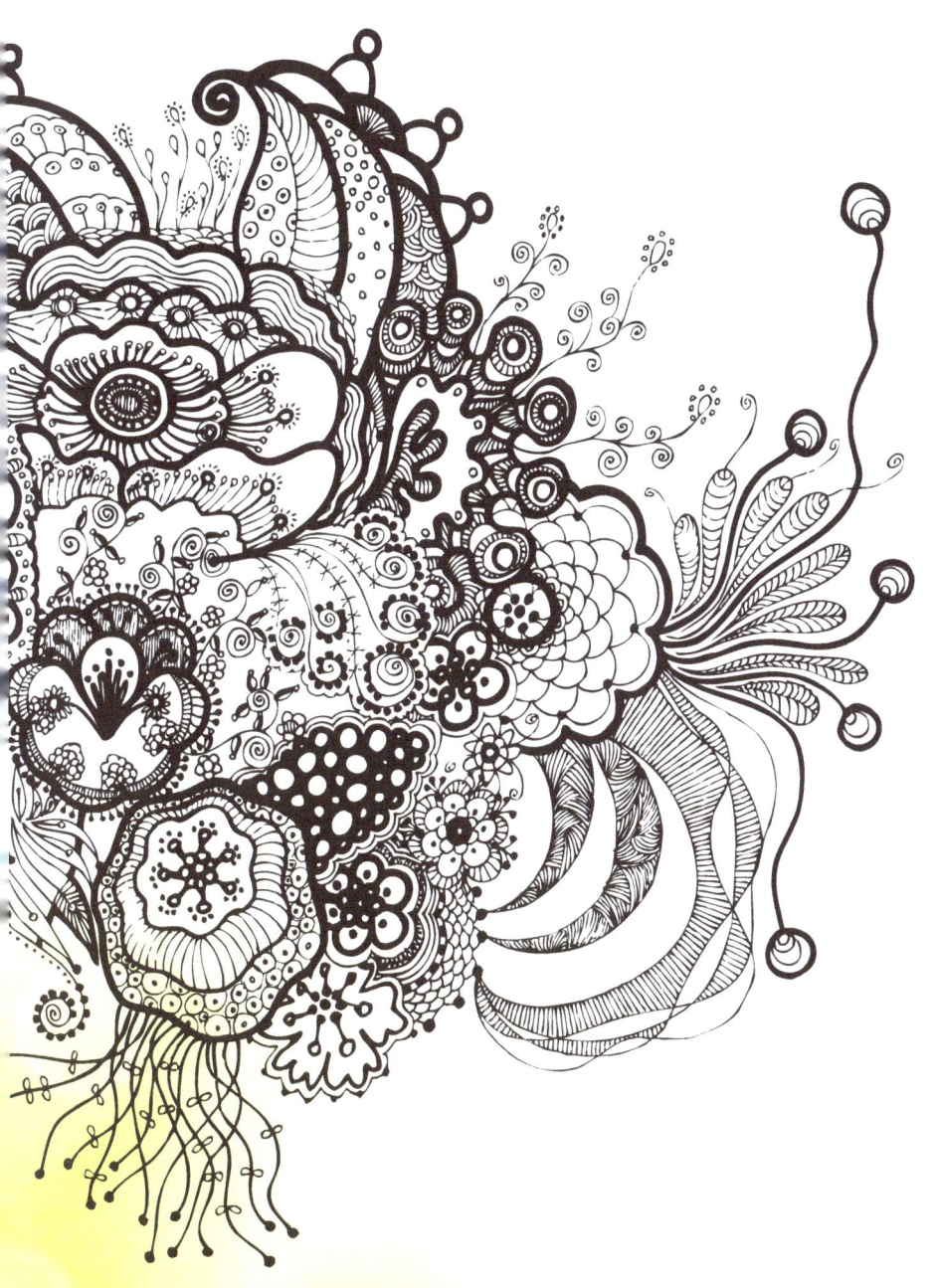

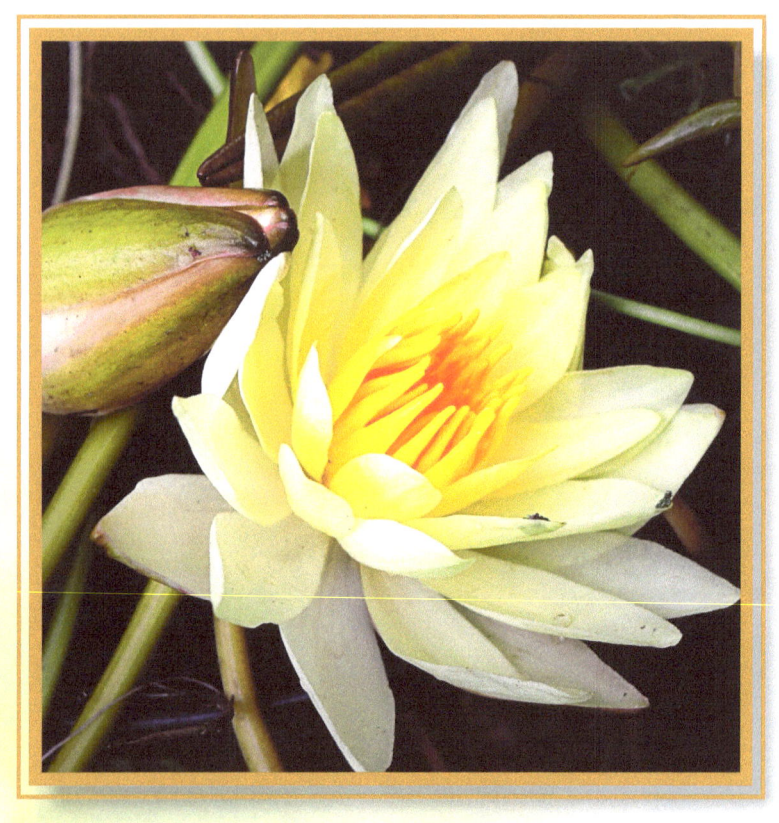

"Your mind believes what you tell it, so tell it positive things."

Jennifer Milius

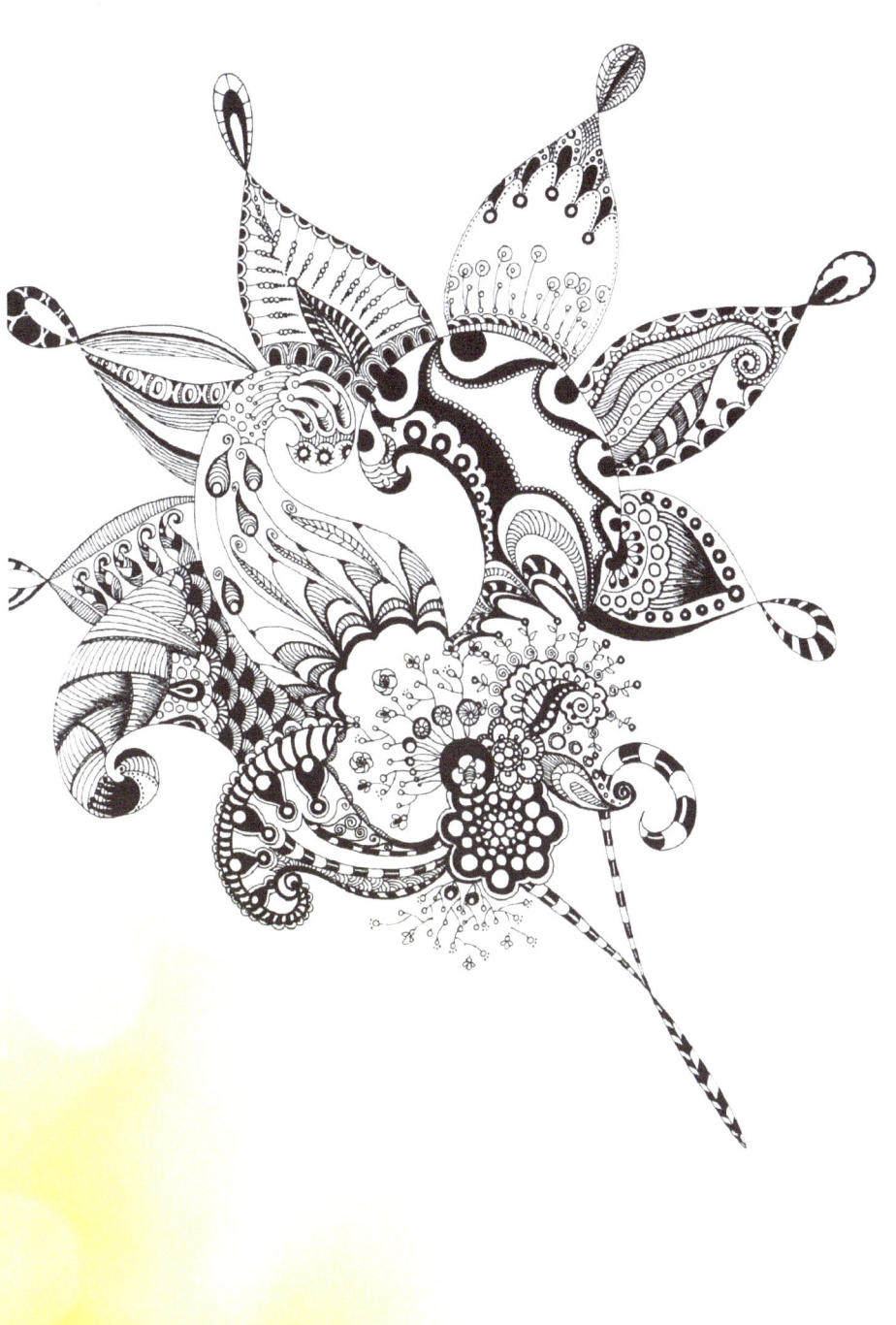

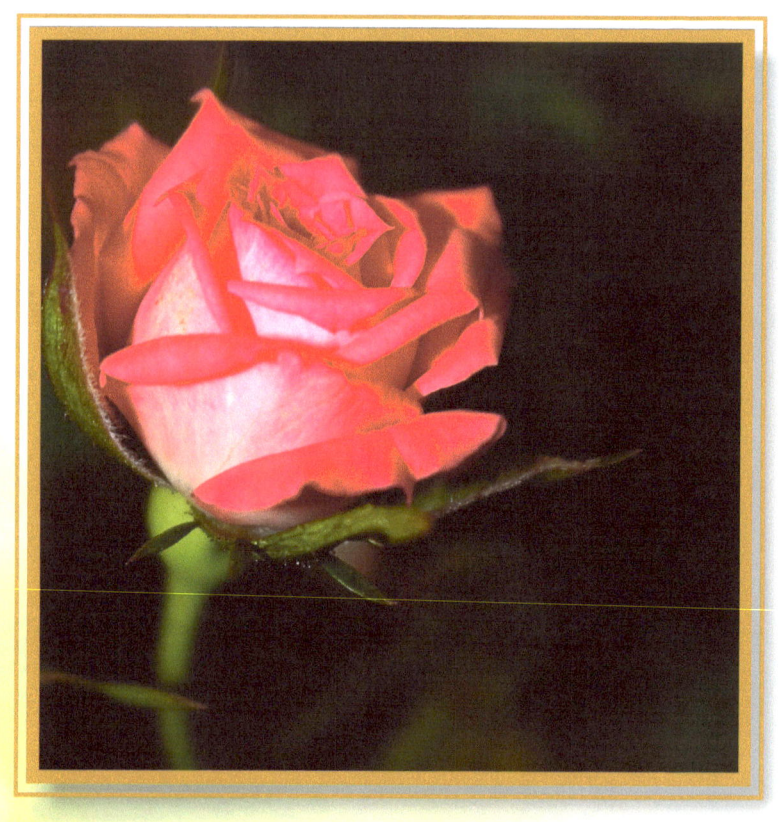

"Live life to the fullest, and focus on the positive."

Matt Cameron

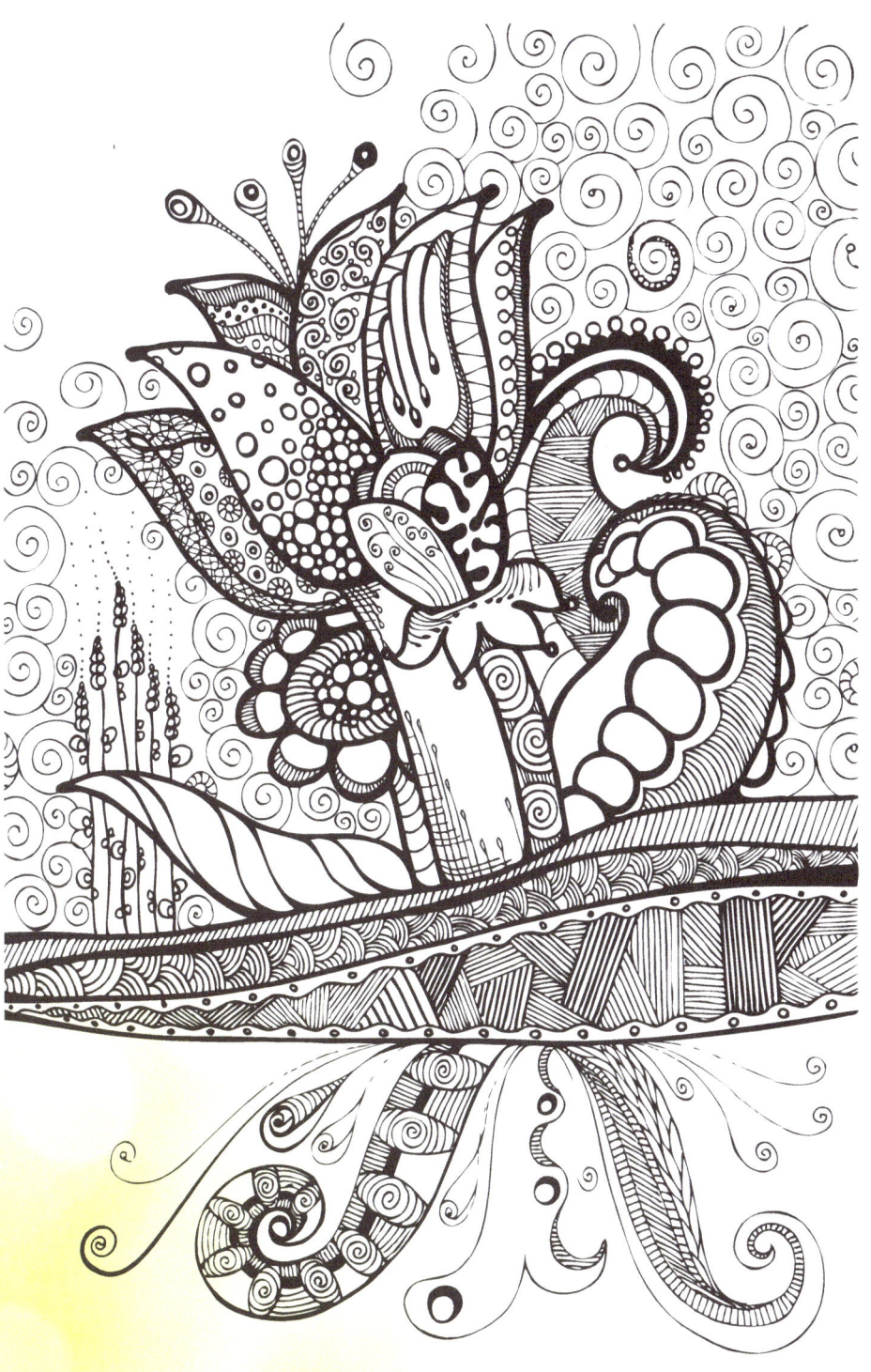

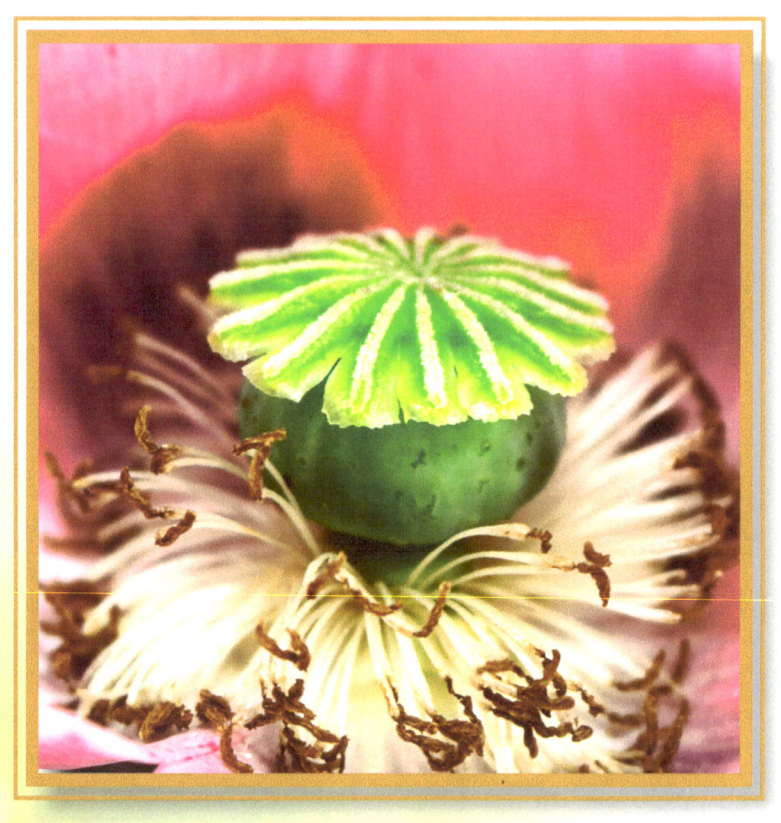

"Good, better, best. Never let it rest.
Til your good is better and
your better is best."

St. Jerome

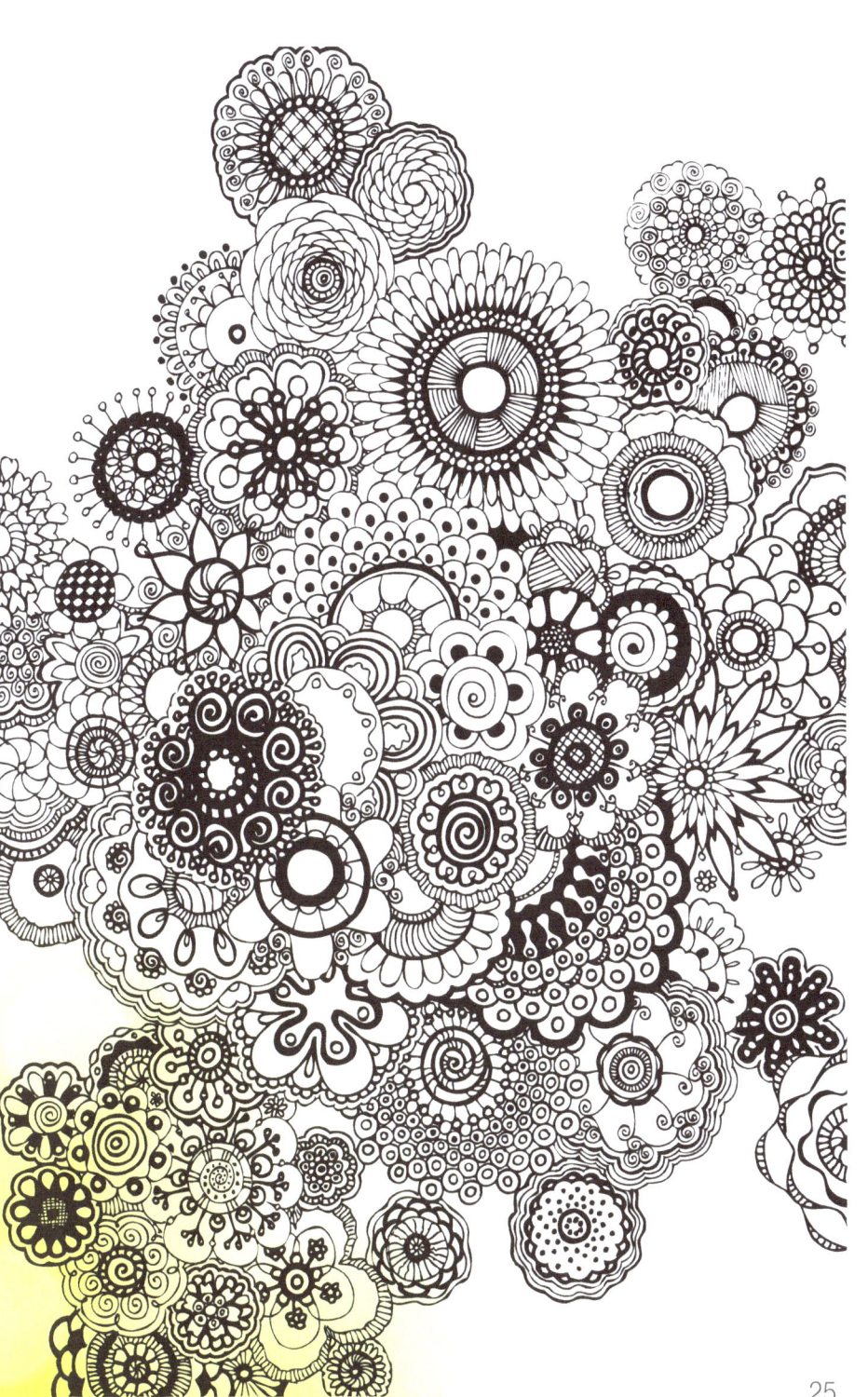

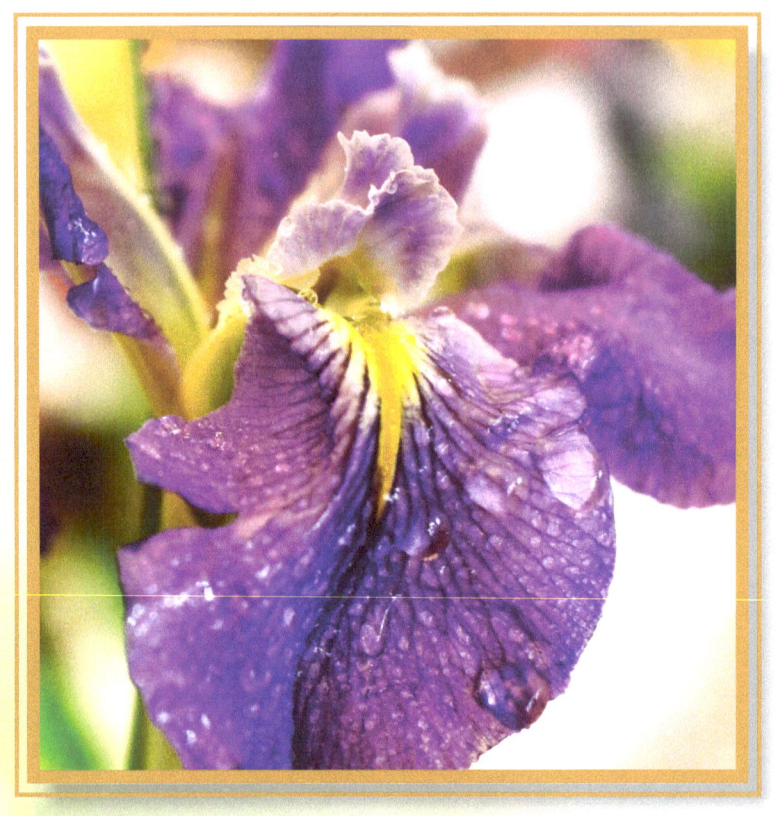

"It does not matter how slowly you go
as long as you do not stop."

Confucius

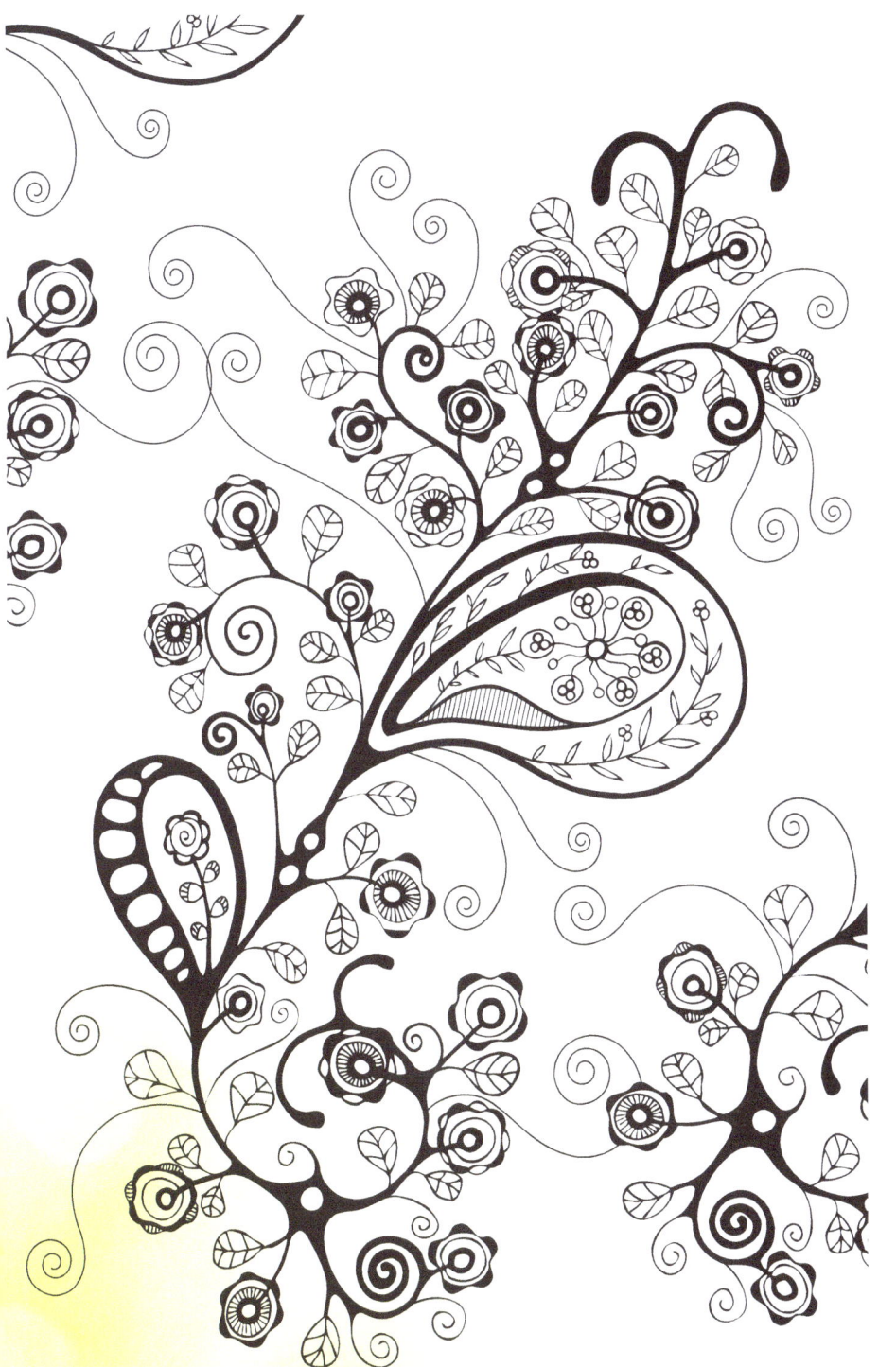

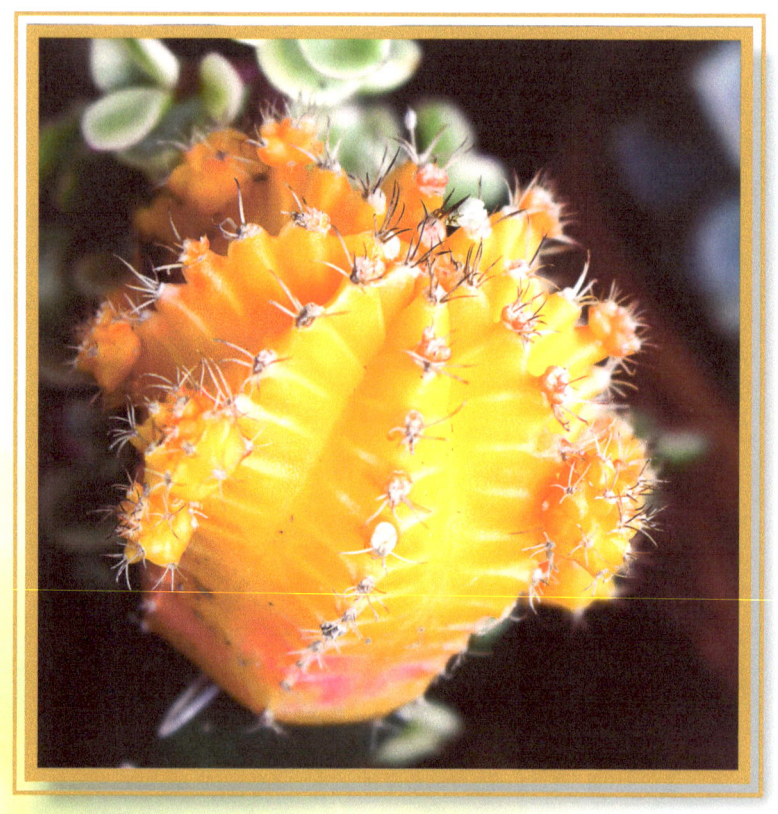

"You are never too old to set another goal
or to dream a new dream."

C. S. Lewis

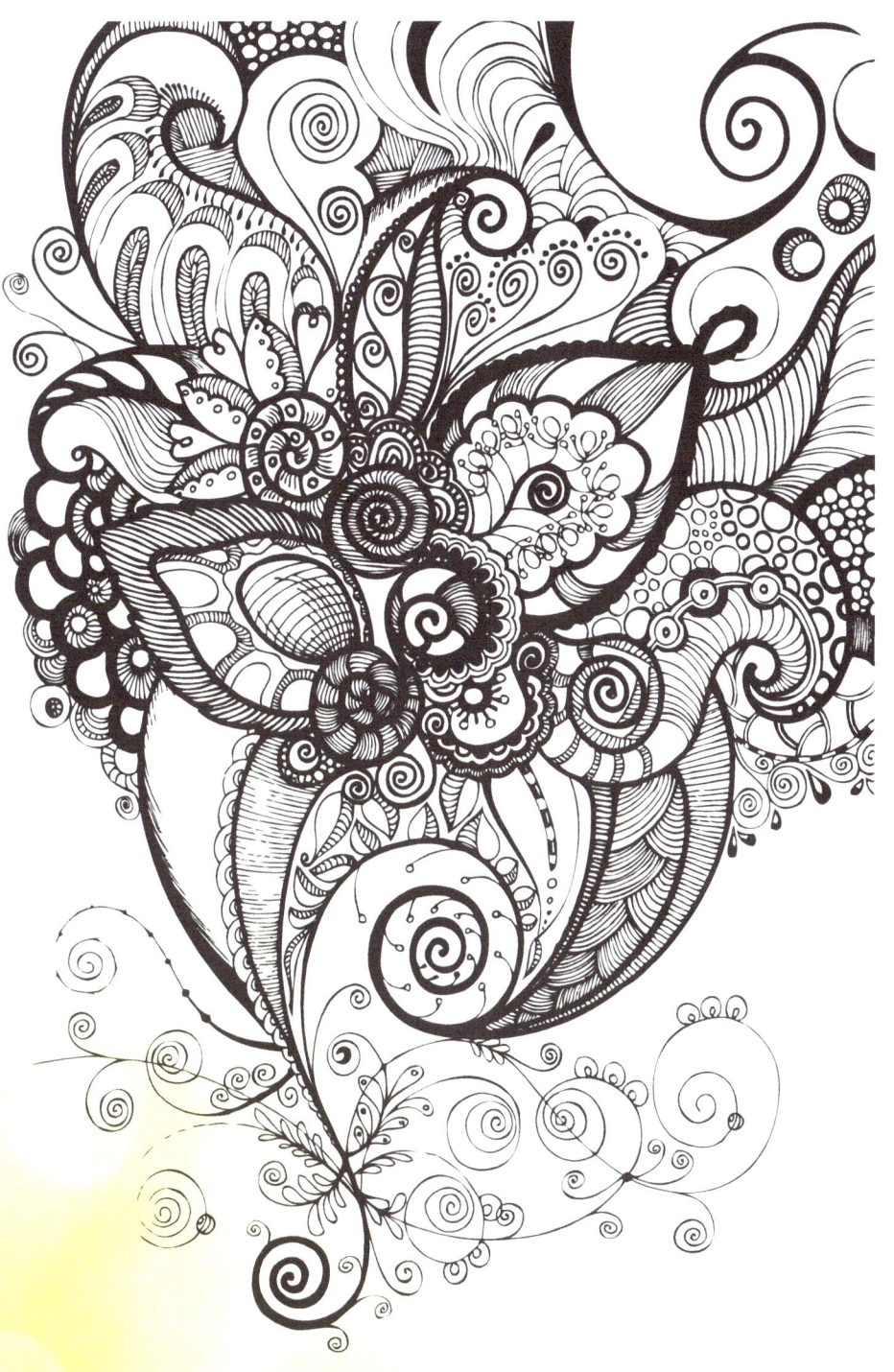

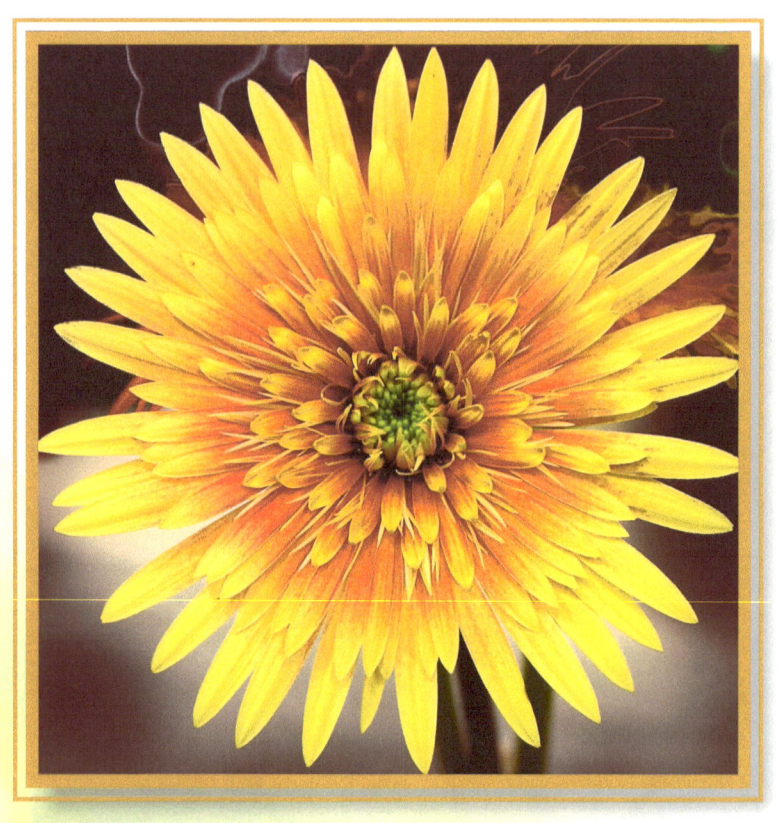

"A creative man is motivated by the desire to achieve, not by the desire to beat others."

Ayn Rand

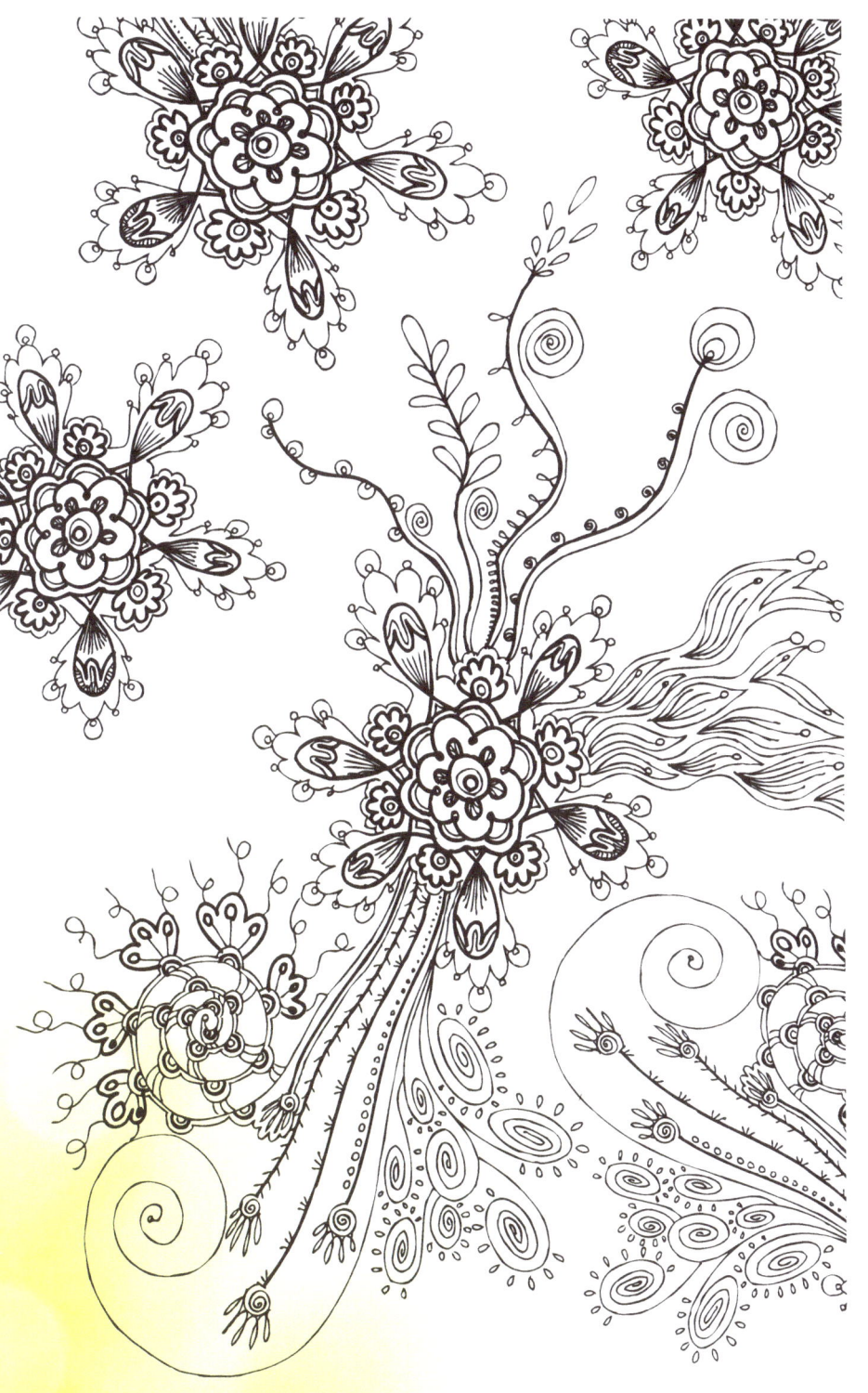

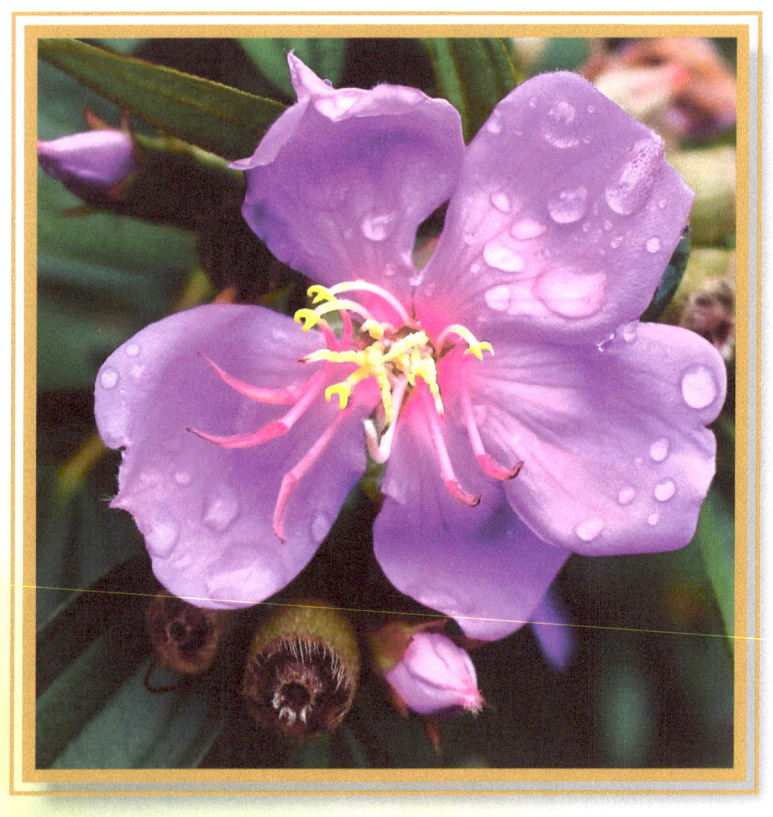

"Happiness is when what you think, what you say, and what you do are in harmony."

Mahatma Gandhi

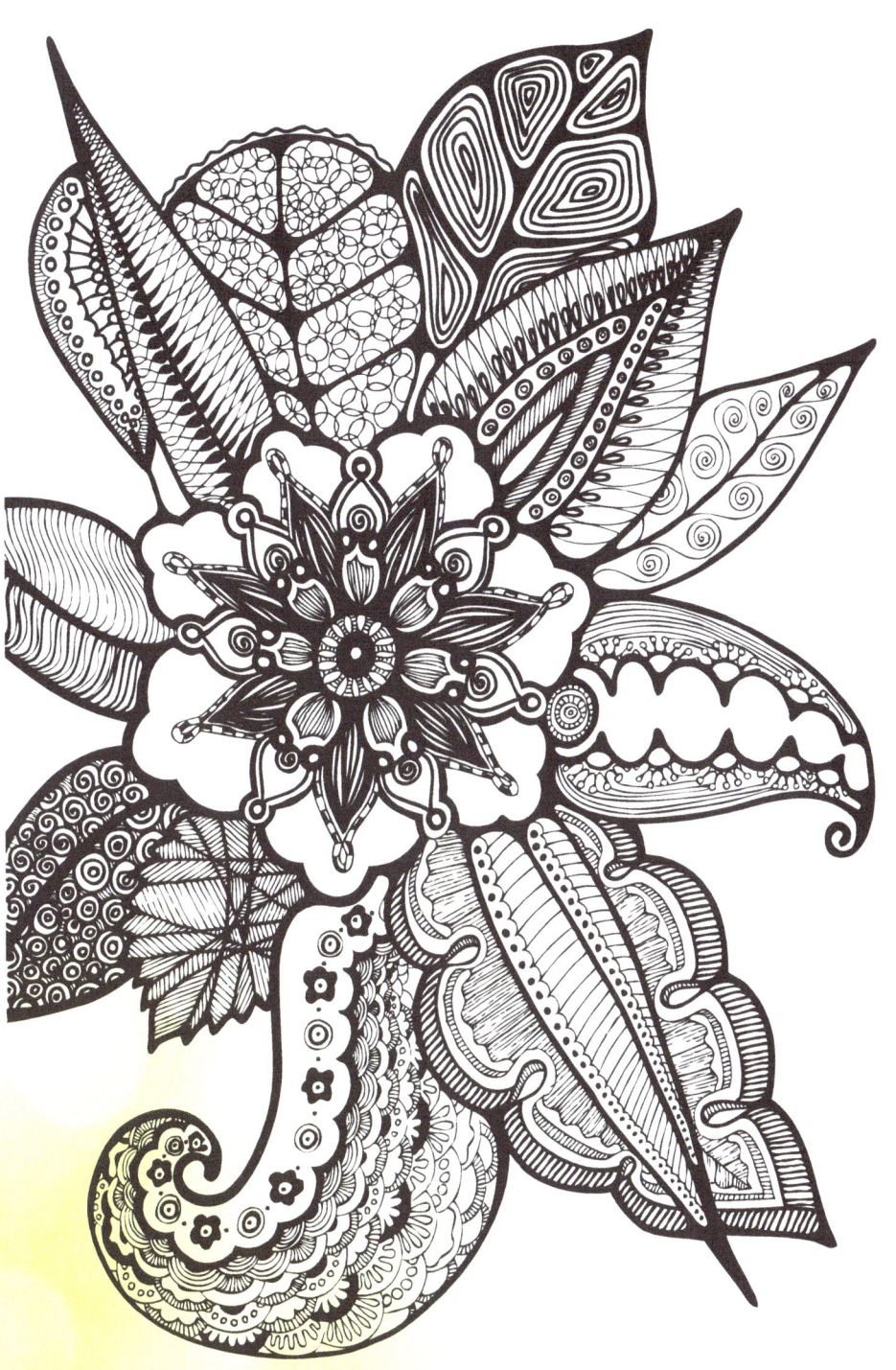

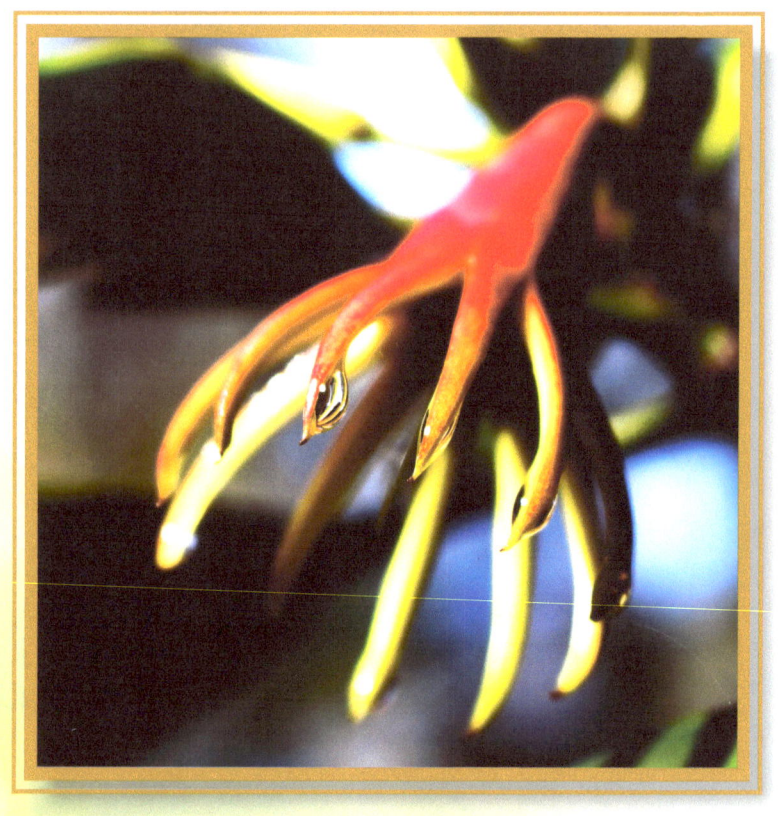

"Action may not always bring happiness;
but there is no happiness without action."

Benjamin Disraeli

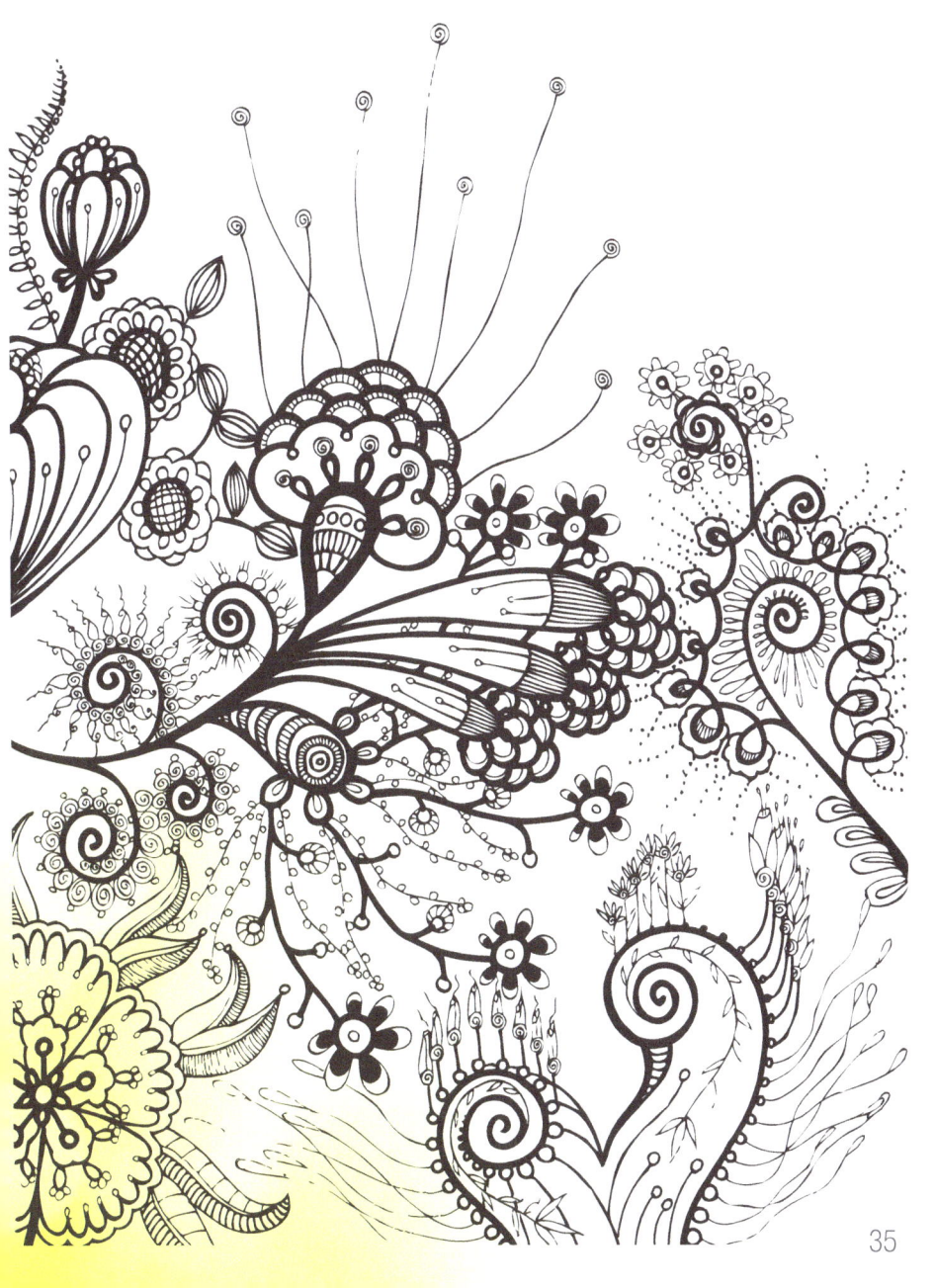

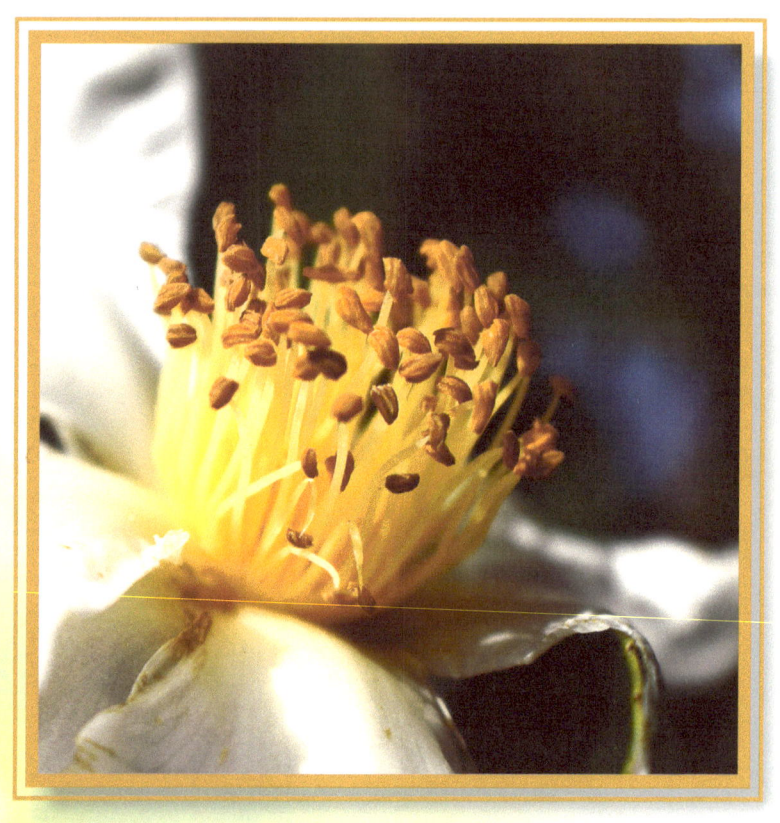

"In the end, it's not the years in your life that count. It's the life in your years."

Abraham Lincoln

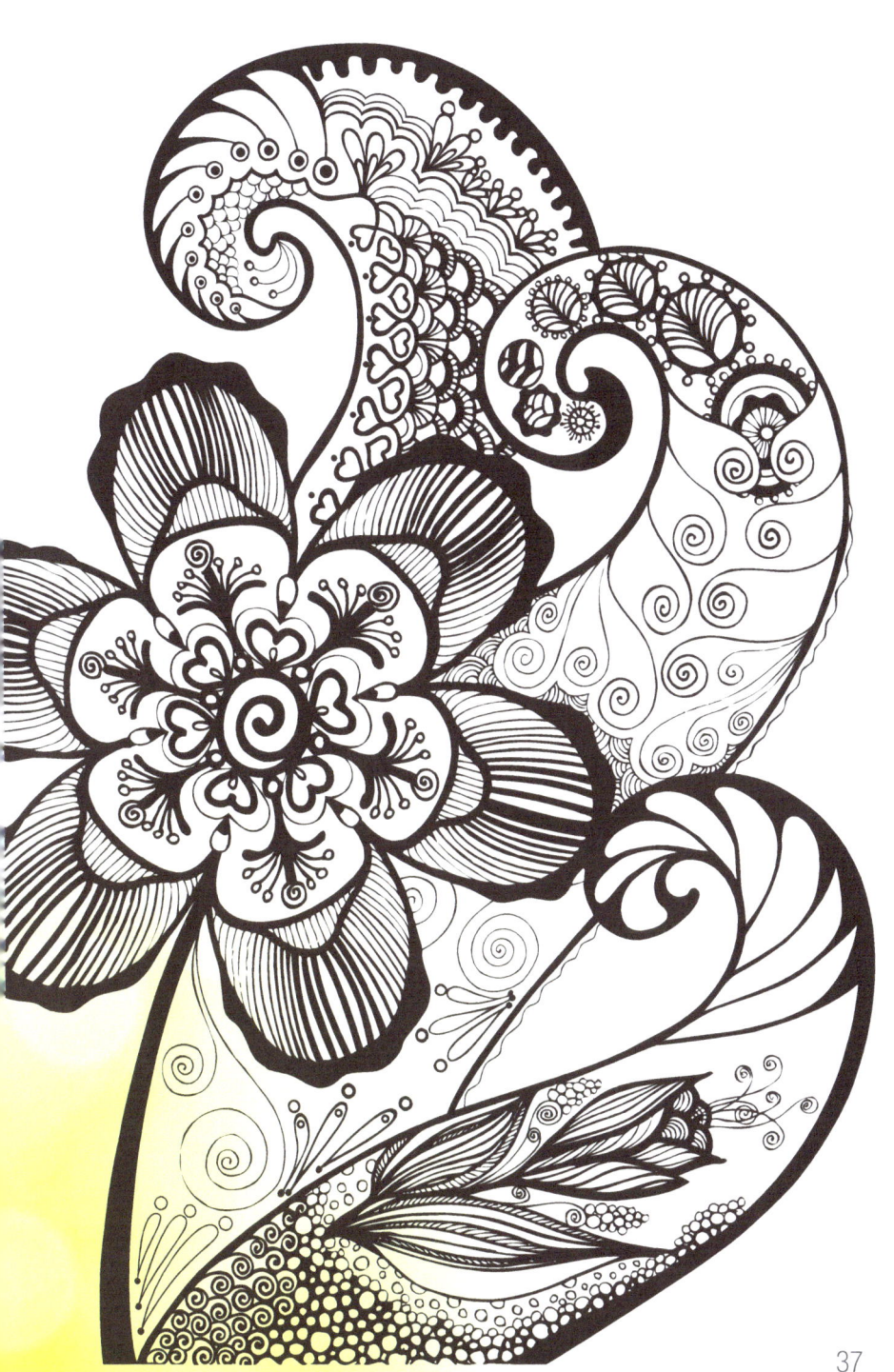

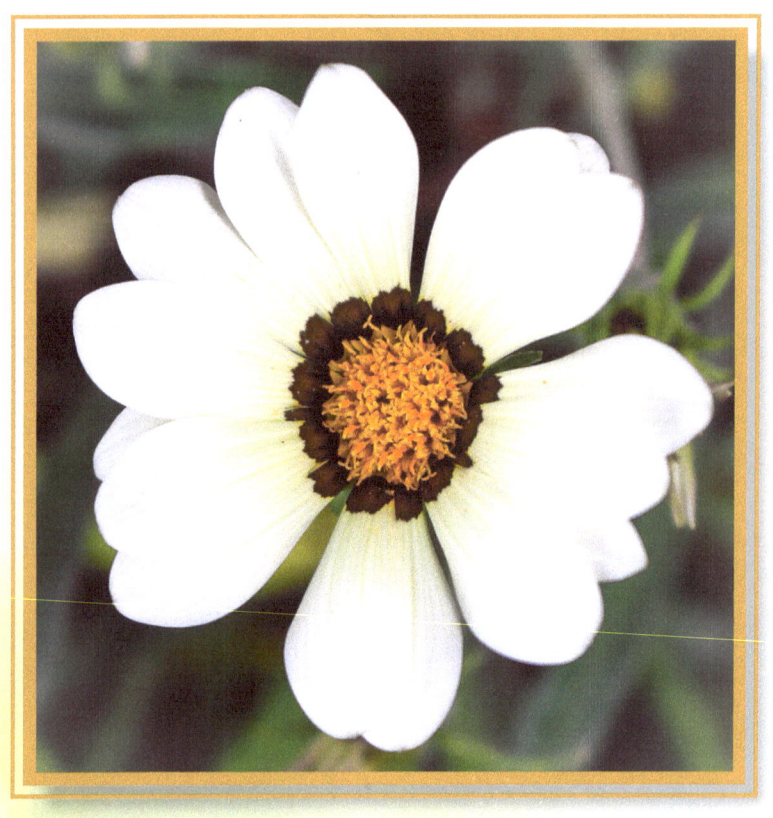

"Our prime purpose in this life is to help others.
And if you can't help them,
at least don't hurt them."

Dalai Lama

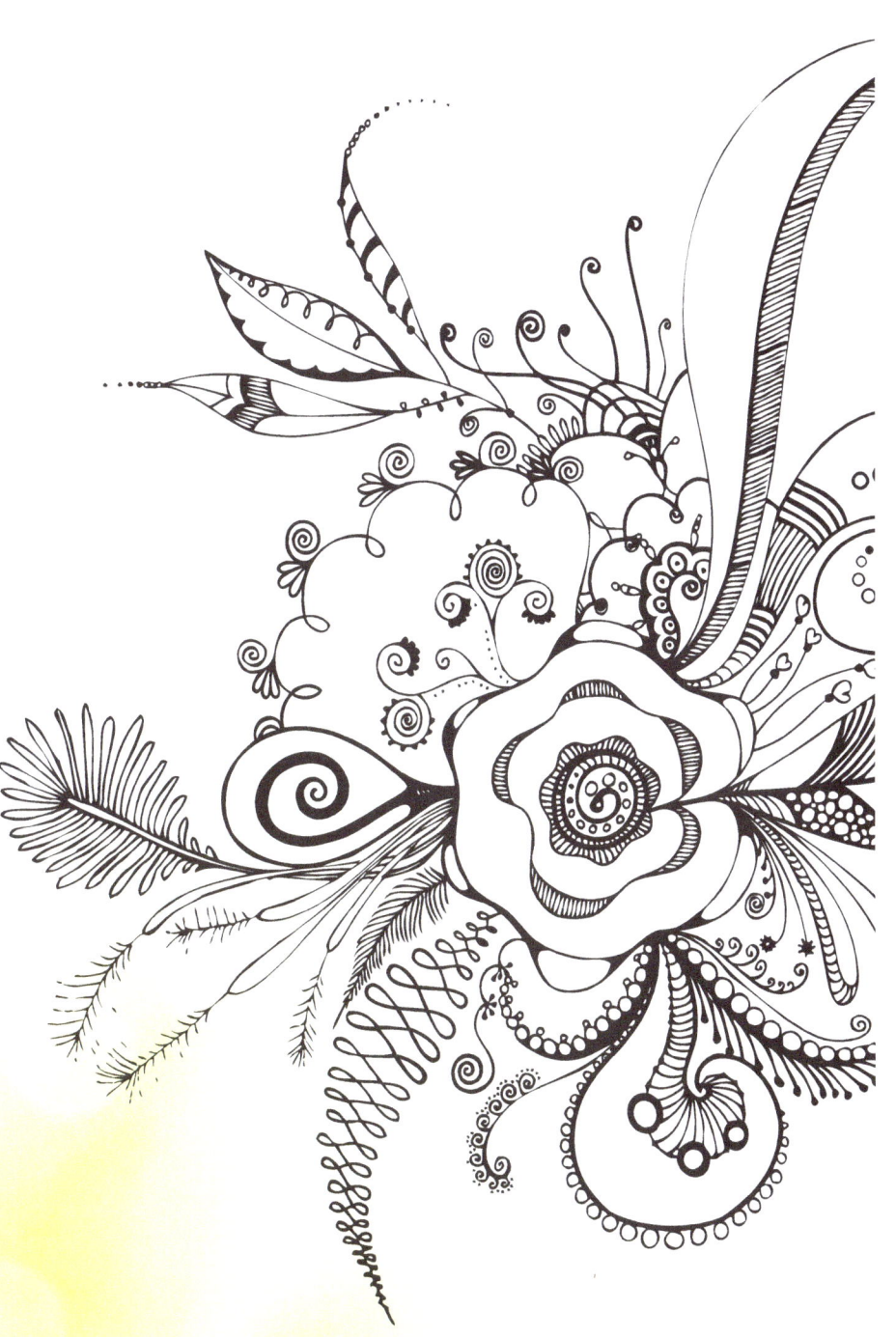

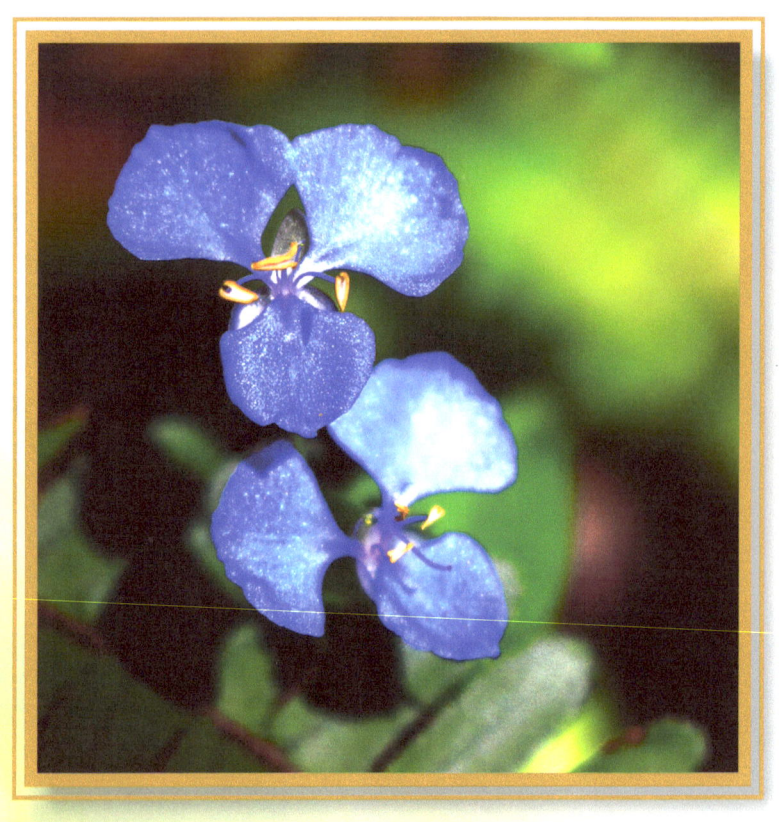

"You have enemies? Good. That means you've stood up for something, sometime in your life."

Winston Churchill

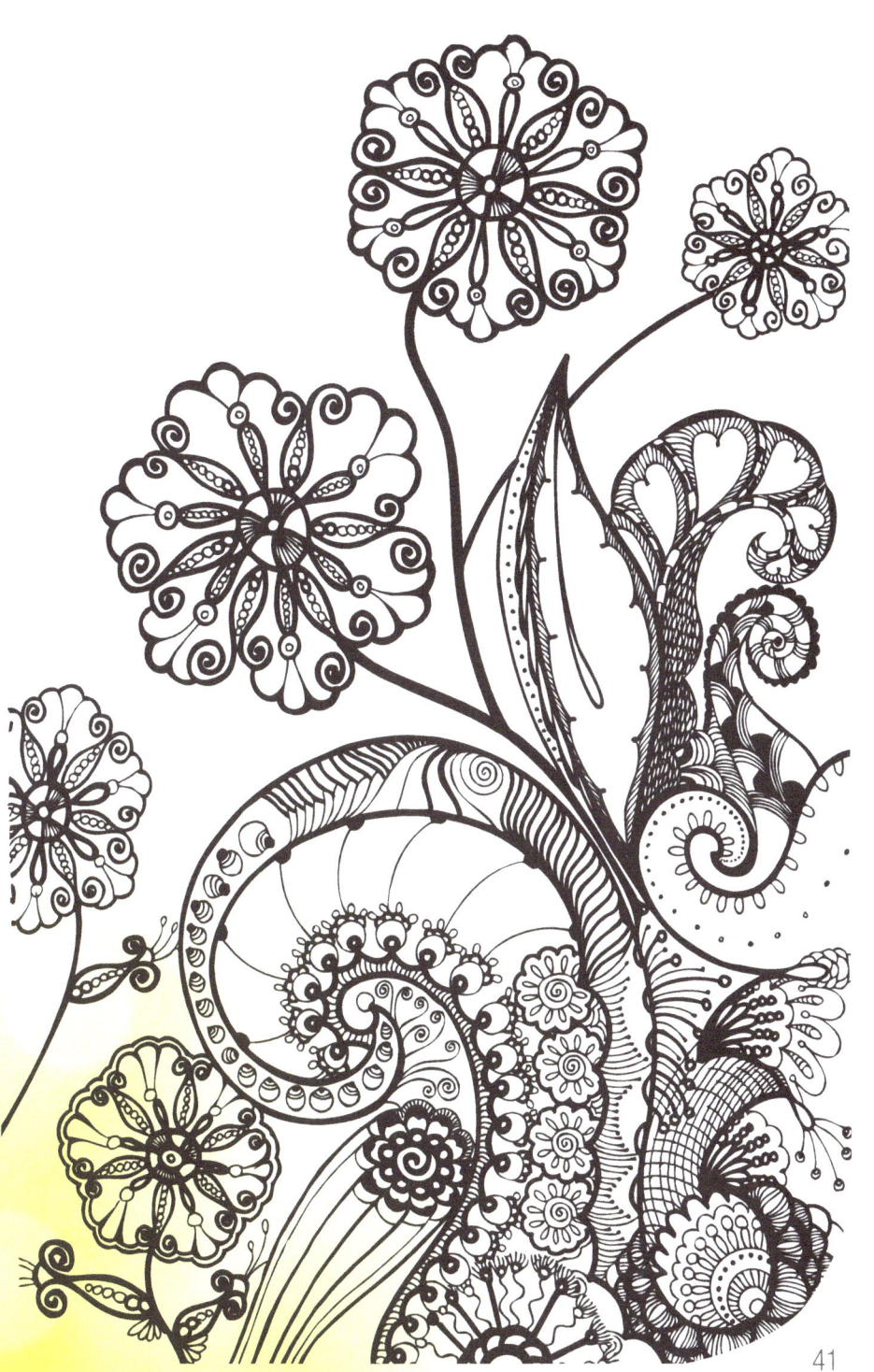

About the Authors

Solé Paez, Australia

Solé was born in Chile and moved to Australia in 1983.

Mother of two, Solé's first love in the creative industry was drawing and painting.

In 1996, this natural talent motivated her to study Graphic Design at the University of the Sunshine Coast, QLD Australia.

Solé's second passion was always photography, making a more serious move into it in 2005 after winning the Maroochy Shire Council annual Photography Award.

Since then, photography has always been in her life, motivating her to manage a large group of photography enthusiasts. These organised group photography sessions make it easier and safer for people to access areas that you otherwise would not go on your own with photography in mind.

Flowers, birds and butterflies are some of the many subjects Solé loves; thus this collection of books came to mind.

E: info@allmediaservices.com.au
PO Box 1099
Buderim - QLD 4556
Australia

Ximena Varas, Chile

Ximena's immediate surroundings are nature, forests, lagoons and these natural beauties have accompanied her always.

The environment has been an important inspiration to Ximena's various activities. Some of her passions are sport and swimming which were her main physical activities through her childhood and youth.

As a child she loved drawing and colouring her drawings, a passion that inspired her to study graphic design. Ximena decided to learn more about what people like; she learned the meaning of colour, forms, space and the power of communicating in black and white, which is used today to reflect her creations.

In this, her first book dedicated to the beauty of flowers, Ximena created multiple and elaborated freehand drawings. The simplicity of clean lines gives character to each artwork, providing assorted graphical representations of flowers and their natural environment.

E: ximenavaras6@gmail.com